Art Now

Fernando Botero

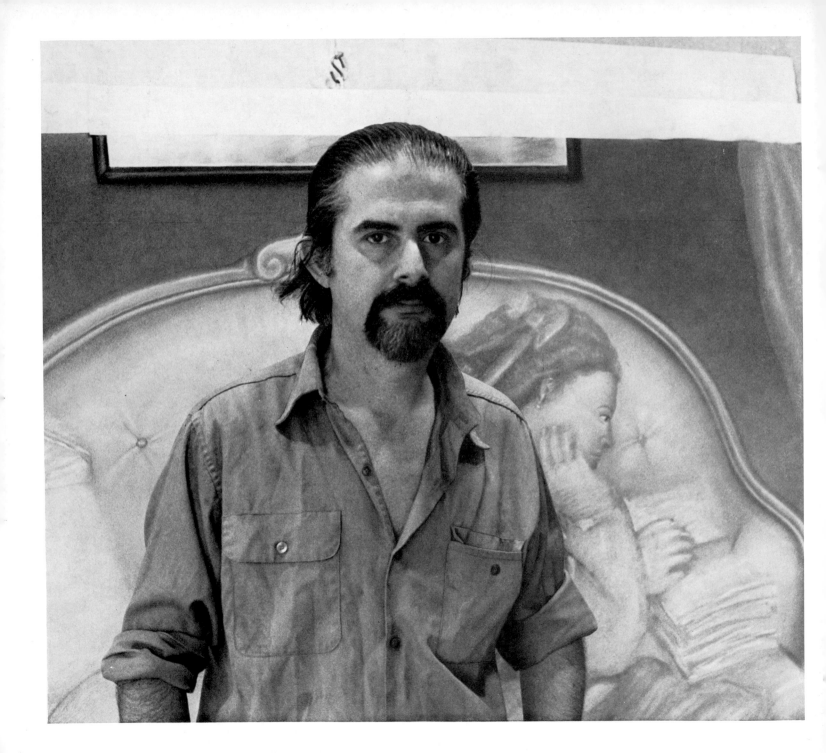

Fernando Botero

KLAUS GALLWITZ

16 COLOUR PLATES, 42 MONOCHROME PLATES

THAMES AND HUDSON

Translated from the German by John Gabriel

General Editor: Werner Spies

First published in Great Britain in 1976 by
Thames and Hudson Ltd, London

Printed in West Germany

Jacket: *Official portrait of the Military Junta*, 1971
Oil, 174×218 cm (68¹/₂×86″). Collection Joachim Jean Aber-
bach, New York

The Paintings

You can let Botero's paintings file past in a strange heterogeneous procession. A little wind band, with archaic shawms, and a trumpet or two, might accompany them in their slow progress with the solemn, measured beat that can still be heard in Catholic countries on Corpus Christi Day. In Colombia there would be a choir singing a mixture of chorales and Spanish folk tunes, coffee house ditties and military marches. One might conjure up the music of Fellini's films, or snatches of classical pieces as background, but nothing really suits such a motley cavalcade better than an authentic Colombian band.

It would be divided into groups—not the orderly kind found in art catalogues, with paintings of figures first, followed by portraits, landscapes and still-lifes—but more in accordance with the changing hierarchy of themes in Botero's work. Let us watch as they go by.

First come the clergy and military. What costumes they have on and what protocol they are observing appear to depend on the current political situation. It seems that the generals are out in front today; they are accompanied by their adjutants, in freshly-pressed uniforms; their horses are like tanks; the classical orders of the Military Hall of Fame provide a suitably imposing backdrop (page 79).

In their wake follows War (page 23): a mountain of corpses, round as the globe itself, and, as inimitable as Breughel's aphorisms or Dante's Hell, the Seven Deadly Sins, hung with battle flags.

Now the saints draw closer. Rising above the rest, we see the head of Christ, martyred, crowned with thorns, suffering all the sins of the flesh of this world, likewise the Madonna, *Our Lady of New York* (page 19), with her child in one arm and an apple in the other. The Passion triptych of 1970 shows them in another pose: Ecce Homo, La Dolorosa, a centurion: a majestic group, their torment laden with flowers, the sign of pain embossed on the arm of their executioner.

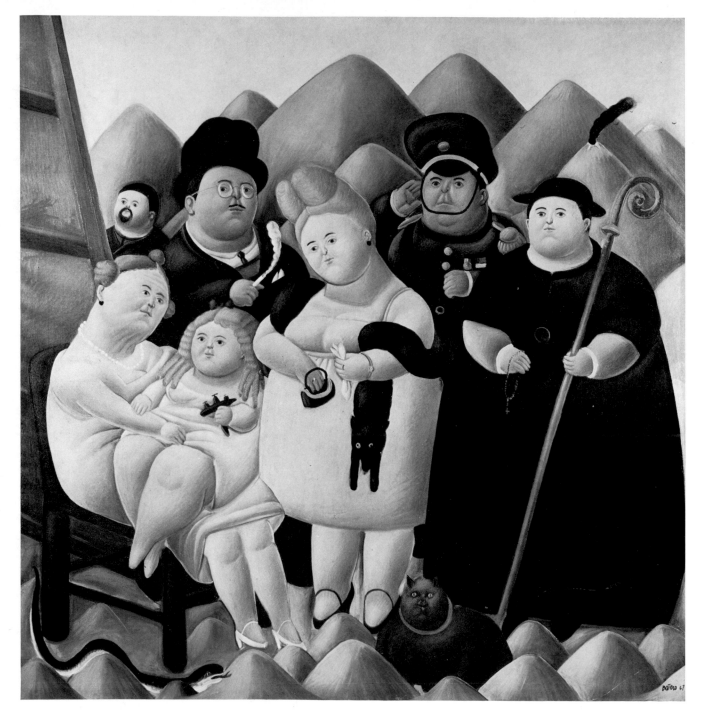

The
Presidential
family,
1967

The sacred leaders are followed by the profane, past and present (pages 6, 77, 78); Madame Pompadour (page 30), rich patrons of the arts, owners of galleries. Claude Bernard, Paris art dealer (page 74), poses as St Cecilia (the patron saint of music and Botero's chosen protectress) before a curtain-like row of organ pipes. Botero's main patron, the collector Mr Frank Lloyd (page 75), is better off, being allowed to enjoy himself (larger than life but otherwise undisguised) with his family on Paradise Island, where the painter has found the promise of a rosy future.

Now come the guilds, the deputations of artists: Rubens is in front, followed closely by the unfortunate Marie Antoinette as Louis Lebrun saw her, and by Velasquez's sad fool (page 72) in his pastel green and white, the tip of his deformed nose looking for all the world like a baby's skull.

Family likenesses are easily caught through their social milieu (pages 11, 12). Those five sisters (page 55), for instance, have definitely seen better days, from the look of the comfortable but rather fusty furnishing of their overheated sitting-room. (The cats, however, seem satisfied enough.) In the garden, family relationships are drawn in bolder, if not simpler, outline. Still, there are certain priorities, not to mention authorities, that command respect.

The Man with the Golden Helmet sitting near the stove: a study (page 76). Another man with his wife on a French sofa (page 58): an idyll in pink and brown, or: Love (of a sort) in the Afternoon. Botero's nudes are as expansive as they are expensive, whether they exude the perfume of the boudoir (page 57) or the naive sensuality of a Bonnard (page 37).

Nor are those proud old matriarchs completely free of conceit as they stretch their wrinkled necks in their lace-trimmed robes (page 20) or pose in rocking chairs flanked by their offspring, fat and mighty cardinals, the

guardians of their untried virtue (page 83). It is simply a question of class, thinks Maruja (page 71), and the melancholy transvestite (page 59) no doubt thinks the same, if with a different conclusion. A *déjeuner sur l'herbe* (page 61) seems far more natural in Colombia, with its mountain panoramas and broad valleys, than it did in Manet's France.

Like his landscapes (pages 60, 62), Botero's still-lifes are free to grow and flourish to their heart's content (pages 44, 45, 63–68). Onions are arranged in voluptuous groups like flowers. Cakes rise to the dimensions of castles (page 16); cornucopias disgorge their legions of fruit (page 70) as though on to a battlefield, to be maimed, dismembered, split asunder—as much an allegory of life's fleeting nature as the deathly pallor of the vegetables, the dry rustling of the onion skins. Slices of iced cake and a boiled swine's head serve only to underline the message: *Nature morte*.

Still-lifes were not only the subjects of Botero's first paintings, they provide a theme that runs through all of his later work—the portraits, the family scenes, the saints and presidents. Since it is painting about which we are talking, let the artist describe his goal: 'What is important is finding where the pleasure comes from when we look at painting. For me, it is enjoyment of life combined with sensuousness of form. Thus the formal problem is how to create sensuousness through form.'

The first Botero paintings that reached Europe about the mid-fifties caused an immediate flurry of interest. There was a whiff of scandal; they were odd, exotic. His inflated people and objects did not seem so much decadent as bombastically sacrilegious. They were not easy to place: with their large format and immediacy of impact they shocked, yet there was nothing in them that would not be found in any classical academic painting—fruit, flowers, landscapes, figures. The difference was that all these familiar objects were so excessively swollen, colossal. Everything that was not ball- or egg-shaped was blown up to bursting point. The sheer obesity of his creatures—children and sinners, madonnas and monks, ladies and whores alike—is the significant factor.

Fat people are said to possess certain qualities in greater degree than their more normal sized fellow-men, among these being good nature, joviality, zest for living and the like. So, after being momentarily taken aback, the usual reaction to one of Botero's paintings is to laugh. An overblown Minister of War in full regalia (page 77), appears not so much moronic as disarming. Not until we are confronted with a corpulent figure wearing a crown of thorns is there a hint of blasphemy.

There are certain misconceptions here, however. Botero explains that he does not consider his figures to be fat at all, on the contrary quite slender. He denies any attempt at caricature. Though satirical intent is implicit in many cases, it does not depend on the subject of the painting for its effect. For all of Botero's work subscribes to one basic precept, which is the transformation of reality into art. Botero prefers the word 'deformation', but it describes the same principle, one upon which all art throughout history has been based. As Botero says, not even Raphael was a realistic painter. Passers-by would stop and stare if one of his madonnas were to come walking down the street. Deformation for its own sake, however, Botero considers harmful, because it ends in monstrosity. At first glance only can Botero be thought a naive artist. His work is too polished and academic; it lacks the

spontaneity, incoherence and disproportion of the naive painting. At the famous banquet in the Bateau Lavoir, Apollinaire overheard Henri Rousseau saying to Picasso: 'You paint in the Egyptian style, and I in the modern.' This seemingly absurd remark draws a useful distinction. In Rousseau's sense, Botero's painting is not modern either, but Colombian, Spanish or Latin American (though he may have appropriated certain naive ways of perception). Just as Picasso made use in Cubism of some formal elements of primitive art, so Botero employs the colonial tradition of South America.

The idol-like character of his figures comes from this heritage. Pre-Colombian art, which Botero collects, and more particularly the colonial art of the region with its stiff and pompously barbaric portrait types, have provided him with ample material for study. The baroque bigotry and cant, the unlimited power of the church and its bishops, the impregnable self-confidence of the beribboned generals and wealthy landowners, the wounds of the saints and their rivers of tears, the leathern, mummified faces of the mothers of ancient presidents—the whole solemn and melancholy tradition of Colombian portraiture reappears in Botero's transformations.

The other problem is a formal one. The size of Botero's figures, the extension of their surface area to the maximum possible has come about in the desire to heighten sensibility. Paradoxically, the same urge leads him to miniaturize other objects, such as the rows of flame-spouting molehills which resemble volcanoes. These tiny mountains have no grandeur but they lend an erotic aspect to the landscape. Proportions in the composition are governed by large and small shapes. As Botero says, relationship is more important than sheer size, for it is proportion that creates the effect of monumentality.

He has put this axiom repeatedly to the test, in both his large canvases and small-format drawings. Botero has noted that his paintings retain their monumentality even in reproduction, and concerning his drawings, com-

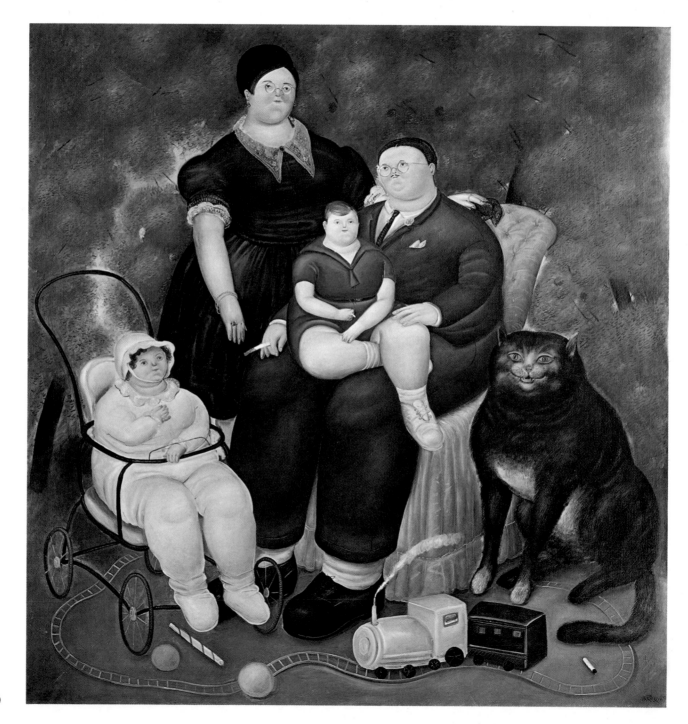

Family scene, 1969

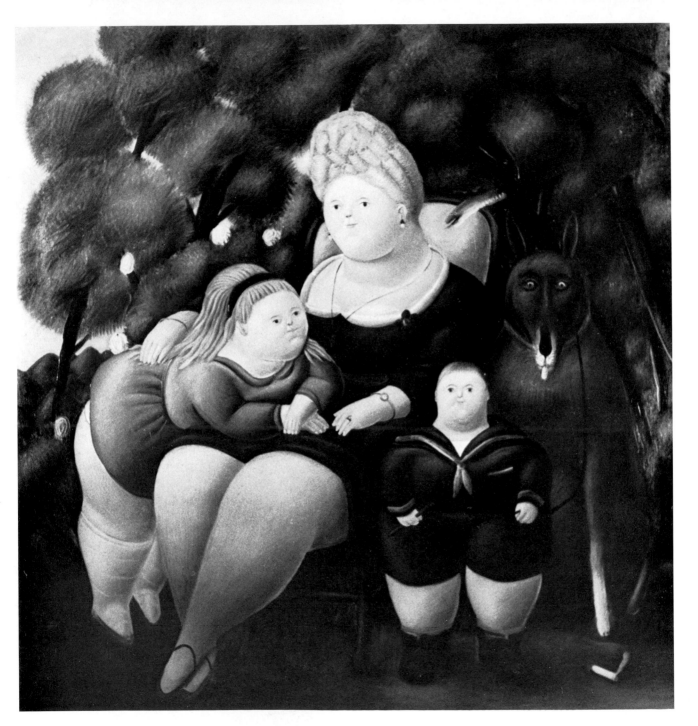

Family scene,
1967

The President
and the
First Lady,
1969

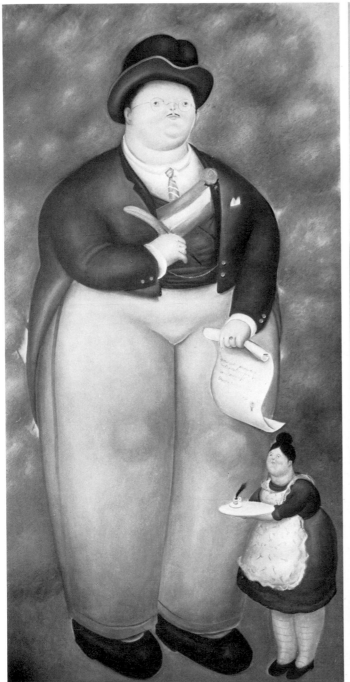

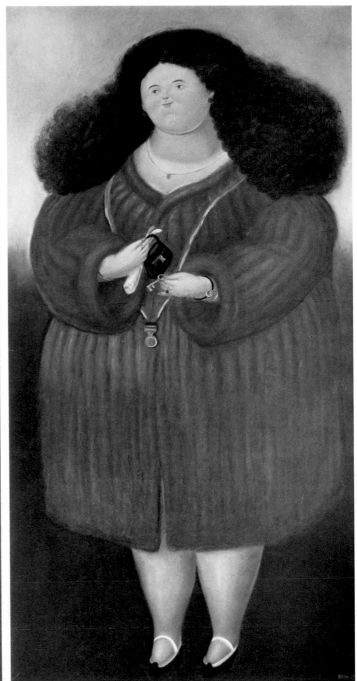

paratively tiny at 16×20 inches, he once remarked to the art dealer Godula Buchholz: 'The forms and little figures—if you look at them close to—appear to be just as large as those in my oil paintings, due to the proportions and perspective I use. When I begin a drawing the paper seems so small—almost impossible to say anything in such a small space—and then as soon as the drawing starts to develop, the paper appears to get bigger and bigger until I seem to be working on a large canvas. In the final analysis I experience drawing as painting with a pencil or pen.' (1971)

The dialectical relationship between form and format is characteristic of Botero's style. He loves to juggle with enormous numbers of objects and figures in his compositions. In this he was inspired by the early Italians with their endless vistas filled with battle scenes, nudes and saints, in which he sees the whole of Creation unfold. Uccello, Carpaccio or Giorgione come to mind.

Vitality and volume of the subject—whether orange or cat or bather—proportion and perspective in its representation: this is the formula Botero uses to evoke the sensuousness that is one of the main qualities of his painting. He has been pre-occupied with this problem all along, as his earliest canvases show, though it was probably his experience of New York that led to the crystallization of his style. His approach to the task was already noticeable in the work he exhibited in Colombia in the late forties: market scenes in watercolour, with plump people handling oversized and awkward objects. The approach had become a method even before Botero's confrontation with the expansive iconography of the New York School and Pop Art in the sixties. Though there is evidence of a struggle against the influence of New York in his paintings of this period, he accepted basically the harshness and isolation of life in the metropolis, its exaggerated and overblown manifestations, everything that the Americans label 'super', and transmuted it into his painting.

The eroticism of his exotic figures, now languorous and now aggressive profited from his encounters with the robustness of Manhattan street life. Despite his ambivalent attitude, Botero was greatly stimulated by the bracing climate. Overwhelmed at times by his environment, he found means, nevertheless, to translate it into pictorial terms and thus his paintings became a true prototype, just as New York itself is a prototype city.

The quieter pace of Paris, where he has been living since 1971, has done nothing to diminish the intensity of his experience. His working method, at once energetic and circumspect, has not changed; his standpoint has become distilled into even greater clarity. For his ten years in the United States embraced a period of intense study of European art history, work that was at odds with the growing confidence of the up and coming generation of American artists, with the Latin American strain becoming increasingly assertive.

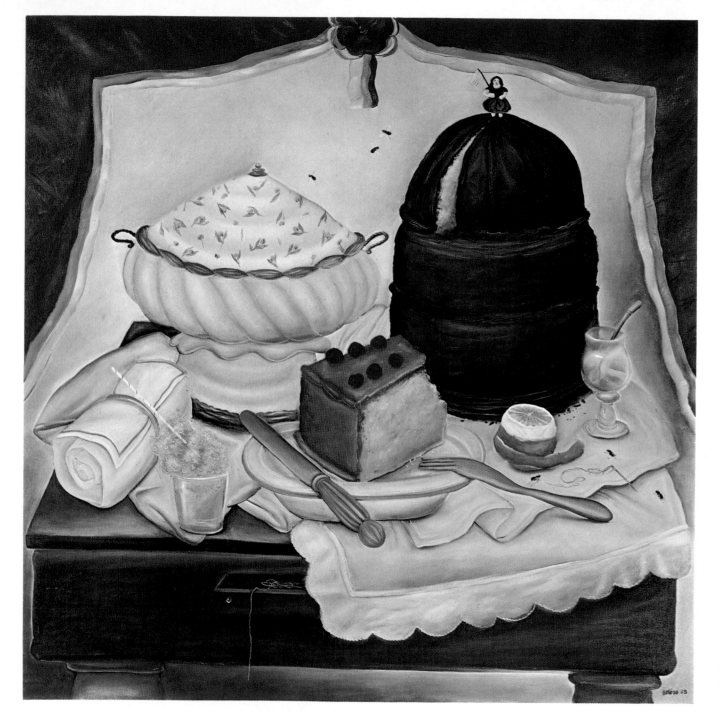

Colombian
still-life,
1969

Colombian becomes artist

Botero's introduction to the world of art came mainly through hours of leafing through art books with repro-
ductions of Surrealist paintings, particularly those of Magritte, in his home town of Medellín. At the age of
eighteen he saw his first original Picasso at the Bogotá Museum. Gauguin was very important to him; less as a
painter than as a person, it seems, whose example served to justify his own *Wanderlust*, the urge to leave his
country for Europe. His early attempts at painting were sporadic: he paid a brief visit to a little fishing village
to paint, and once had an opportunity to design a stage set for a Spanish theatre troupe that visited Medellín. No
matter what he undertook, he was unable to shake off a deep-seated feeling of inadequacy, so with the first
money he earned he booked a passage to Madrid to study drawing at the Academia San Fernando. He worked
there from models, and plaster casts, but soon realized that his real teachers were not to be found in drawing
class but in the Prado where he was given permission to work.

As the result of his year-long stay in Madrid he developed iron discipline in his habit of work, and completed a
series of studies after Velasquez and Goya, which marks the beginning of his own style. Conversations with a
professional copyist, who could turn out a Velasquez *Borrachos* in one day, gave him food for thought about the
connection between virtuosity, technique and intuition. His first journey to Paris was a disappointment: beside
his 'own' Spanish painters, the French twentieth-century work that he saw in the Musée National d'Art
Moderne, which had excited him the first time he saw it in Colombia, paled by comparison. Instead of leading
him on to Manet, Velasquez pointed the way back to the Early Renaissance—to Giotto, Mantegna and to Piero
della Francesca.

He attended Roberto Longhi's lectures in art history in Florence. While the first triumphs of Tachism and
Abstract Expressionism were being celebrated, Botero was studying how a line can be used to give the effect of

volume without the aid of shading, and how line and colour lead to form. Once more he subjected his work to the discipline of a careful technique. For eighteen months he worked like a Renaissance master.

A show of his work held on his return to Colombia in 1955 was a fiasco and he was rejected by his friends as a 'museum painter'. He realized that provincial Colombia was abreast of developments in contemporary art and, disappointed and exhausted, he gave up painting entirely for a year. Then, in Mexico City, he came across two artists, Diego Rivera and José Clemente Orozco, who seemed to him to provide the missing link between the Italian Renaissance and the art of this century. A second show, this time under the auspices of the Pan American Union in Washington, went better in spite of rough treatment by the critics who thought the ugliness of his subjects too arty, their grotesqueness too elegant, their treatment lacking the drive of the contemporary American painters. But Botero was already involved with the New York School and he admired De Kooning and Kline for the freedom of their compositions and sheer power of brushstroke. Again he found a positive way out, accepting the challenge and provocation of New York life. His academic training and penchant for monumental scale gave him the technique, and his distance from Europe and Latin America the setting he needed fully to develop as a painter.

At the age of forty Botero returned once more to Paris, this time apparently to stay. His return was made easier by the success he had had in a number of exhibitions on the Continent, particularly in Germany.

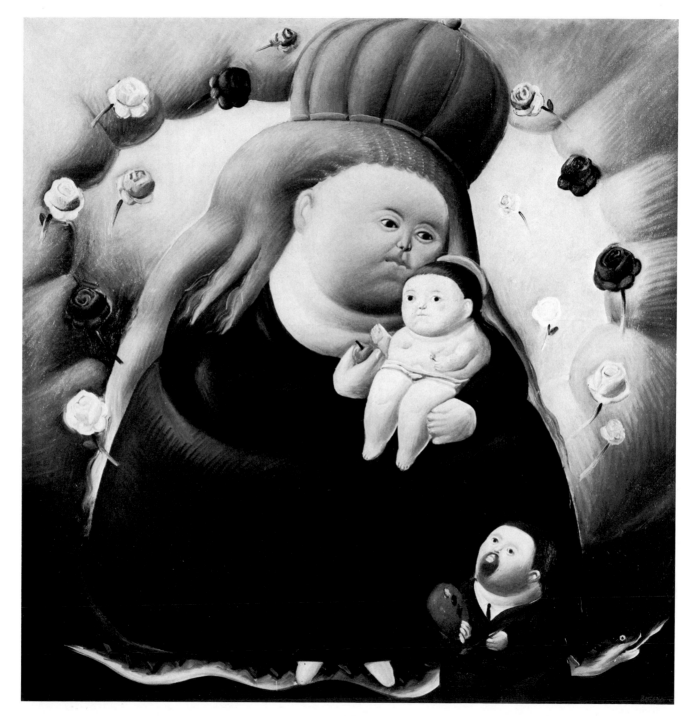

Our Lady
of New York,
1966

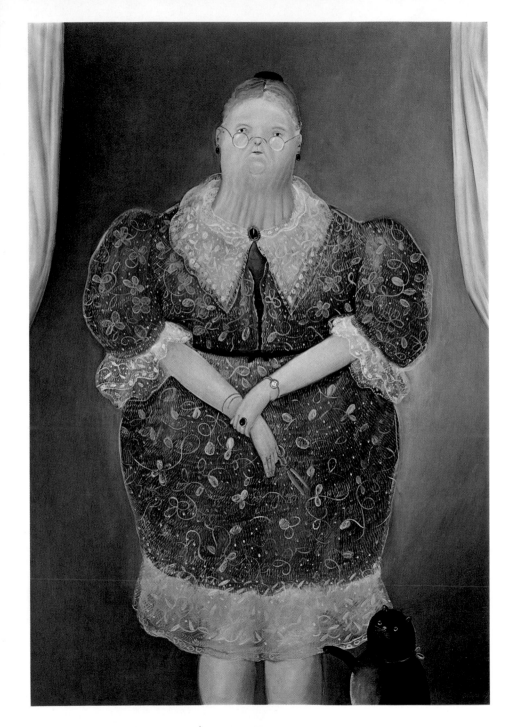

Grandmother, 1969

The Revisionist

Botero works hard; when he is not painting, he devotes himself to the study of art history and theory. His productiveness is a reflection not only of his mastery of the painter's craft and the routine this mastery brings with it, but also of continual efforts to define and clarify his standpoint, weigh his thoughts, and criticize his own development. After a long period of working in oils he may turn suddenly but purposefully to drawing, or to pastels, or, most recently, to first attempts at sculpture. He explains these change-overs in terms of his need for training—to gain perspective on his own work, avoid one-sidedness, and to keep his hand in all the artistic disciplines. Economic considerations may play as large a part in this as the need for self-criticism and the desire to put past successes into proper perspective.

He has had much too rigorous schooling not to want continually to check and compare, register progress, do better next time, and in general be his own hard taskmaster. He may be dissatisfied with drawings made only a few years ago because the figure and background do not work together. In overcoming 'failings' of this kind, he comes up against new problems.

He invariably goes to see his own shows, and may even use the chance to make revisions. He says the 'focus' an exhibition gives him on his recent work helps him decide where to go next; he is less interested in corroborating what he has achieved than in finding out what he has not. Botero is really one of his own most exacting critics. Just as he has always learned more from artistic practice than from art schools, art history, or art criticism, he looks at his own paintings as material to be sifted for new insight. As an artist he is a true revisionist, one who is in continual process of revising his own work and the work of others he respects.

This is also why he follows a formal canon, both in his painting and in his life. A good host and a good conversationalist, he has devoted himself for years now to society portraits. He loves an extravagantly decorated table,

overflowing baskets of fruit, lush bouquets. His still-lifes reveal a gourmet to whom taste is more important than tastiness. To him a picnic—the classic *Déjeuner sur l'herbe*—is still a masterpiece of culinary eroticism. He accentuates the piquant without injury to the conventions of the scene. Sweetness has no bitter aftertaste with Botero; rather, it begets more of the same.

The effect of a fine glaze, such as that on candied chestnuts, shimmers on the surface of many of his paintings and increases the impression of the noble, understated, odourless presence of art history and painterly culture. Even pedantry and ritual repetition have their place in these mute plays. The bearing of the painter and his models, for all its occasional aggressiveness, is genuinely phlegmatic and so perfectly suited to their social position that one can conceive of no change in it for ages to come. Nowhere is a tendency to allegory or agitation to be found, no idealistic superstructure to be detected. Social criticism is conspicuous by its absence; unless, of course, one thinks of Botero as an 'unconscious critic'. What speaks against this interpretation is the stylistic objectivity of his scenes, figures, heads, still-lifes and portraits, an increasing number lately being self-portraits. He identifies with his 'guests', with women of ill-repute as well as society ladies. He gathers them around him, invites them to luncheon, eats with gusto, observes his duties as a host, and goes about his business. Small gestures of kindness, middle-class gentility, the everyday and the mundane are just as important as politeness, distance, humour and melancholy.

Even if clear and all too simple parallels arise between style of living and style of painting, and though purposeful normality may serve to stabilize his personal and artistic relationships, the picture of Botero's hard-working, economical, and self-reliant existence is still misleading. His life is respectable and conformist only on the outside, and this for a good reason—solely under the constraint of a regular schedule and habits can the kind of

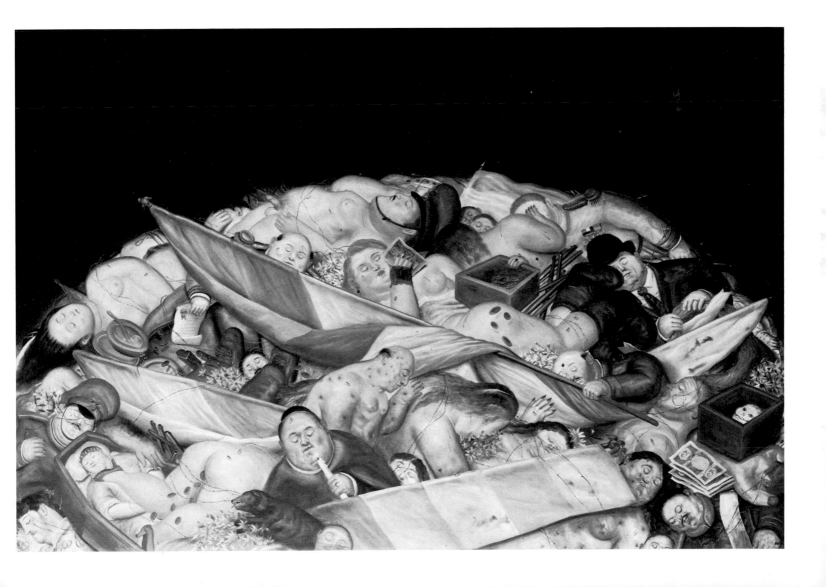

imagination thrive that is fed not only by inspiration but also by suggestion, which requires infinite pains to be moulded into concrete form. Is not Botero's particular achievement to be found in the kind of epic montage typical of his paintings? If so, the sublimation of the material he has gathered from his Colombian background may provide a key to understanding the themes of his painting.

These may be trivial or poetic, realistic or topical, but they are not based on any deep-seated desire to cure society's ills. His paintings are really not anti-clerical, anti-militarist, anti-bourgeois; the impression misleads. Botero does not deny that he draws continually on personal experience and from memory, and he follows events in Colombia just as avidly as politically engaged compatriots. His long stay in New York sharpened his feeling for social and political repression. This is why his bishops, ministers of war, and presidents are often only too recognizable.

His first 'battle scene' (page 23) was painted during the military *putsch* in Chile. He knew full well that people were sitting and drinking champagne on the balconies and penthouse terraces of Santiago while they watched Allende's villa being levelled by bombs. Yet rather than making this macabre point in his painting, he wanted it to be a conventional battlefield scene with blood and corpses. At least this is what he says. The event loses its historical connection, its private feeling, its political motivation. But danger and evil remain. Some of the changes that came about in the scene during the act of painting are no doubt due to what Botero describes as his 'love' of his work, a love that extends even to the representation of horror.

'Latin America is one of the few places left in the world', he says, 'that can still be transmuted into myth. People generally have very vague ideas about Latin America, and that is a good thing for an artist. Places that have been explained too thoroughly, which people are tired of hearing about, offer hardly any opportunity for poetic

transformation. The artist tells a "lie", something that isn't true, but it becomes the truth about that country in time.' This kind of truth about Colombia is bound to disappoint anyone who expects hard and fast political comment. What is all too easily overlooked is the fact that Botero's painting has already transformed its traditional subjects into something new.

Botero's hard-won virtuosity, style, and expressive means seldom hide the subconscious origin of his themes. Just as the Blues were the catharsis of the slave experience for the American blacks and its expression in musical terms, so Botero has begun to tell the story of South America by distancing himself from it.

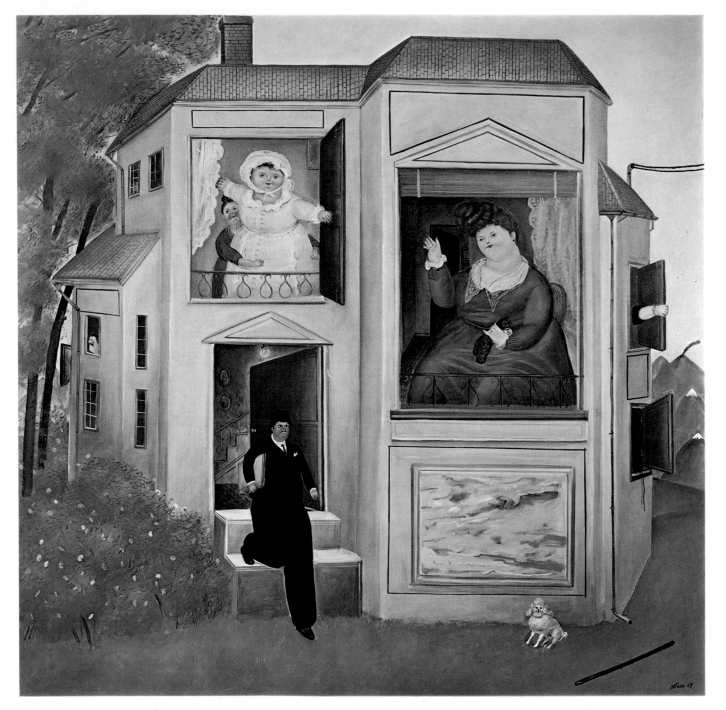

Man
going
to his
office,
1969

Man going to his office

Botero once chanced to say that he was doing something very much concerned with a certain place, in fact provincial. Behind this statement lies the knowledge that his painting deals with a remote subject, namely South America, on which he is an expert. He is plagued by the thought that his ideas continually run contrary to those of other painters. For all his cosmopolitanism he has remained a loner with an obsession, and personal contacts have neither disturbed nor influenced him. He feels no particular ties and could paint his pictures anywhere in Europe or America (with the possible exception of Colombia, where he would be too close to his subject). But his work thrives in the air of the big city, its civilization, comfort and congestion. He also needs museums and exhibitions, and the commercial galleries. This insight came only with success, after a long period of believing he could manage independently of the art market. In New York he admitted that he must be a masochist to want to live there, and that money was probably the main reason he stayed.

His addresses have always been correct, even highly respectable: Fifth Avenue in New York and in Paris, Boulevard du Palais, across from Sainte Chapelle. His rooms have invariably been capacious and well appointed. The things with which he surrounds himself indicate a desire to distance his private life from the outside world. Ensconced among his Colombian saints and fine furniture, Botero receives his guests graciously, with the old-fashioned airs of a man consciously master of house and hearth.

This somewhat weighty role, allowing as it does of no bohemian confusion of art and life, will surprise only those who overlook Botero's strict separation of the domains of home and work. He leaves his house every morning to go to his 'office', his studio, which is within walking distance. Each day he takes the same walk to work, whether in New York or Paris. There is something 'local and provincial' here, not only about his paintings; a touch of pedantry about his working habits serves to increase this impression.

After almost ten years in New York, in 1969, Botero painted his *Hombre yendo a la oficina*–'Man going to his office' (page 26). This small format painting shows nothing but that moment of the day, any day, when the man of the house leaves for work. It is almost too anecdotal, with a touch of naiveté thrown in for good measure. The proportions of the house and the placing of the windows remind one of those first popular broadsheets illustrated with rough woodcuts. The woman waves a cheery good-bye to the man in the neat black business-suit–her husband? Yes, but also Everyman.

One can sense the pleasure Botero must have had in painting this scene. It communicates the humour of this everyday occurrence beautifully, and although it contains no direct autobiographical clues, we can decode at least one satirical detail–the miniature abstract painting that adorns the façade of the house, carefully framed, flattering with its presence not only the lady of the house, enthroned above it like a monument to herself, but also the little dog which, awestruck by so much art, poses before the painting within the painting.

The reality a painter sees on the way to his studio is translated by him into art. After all, that is his job.

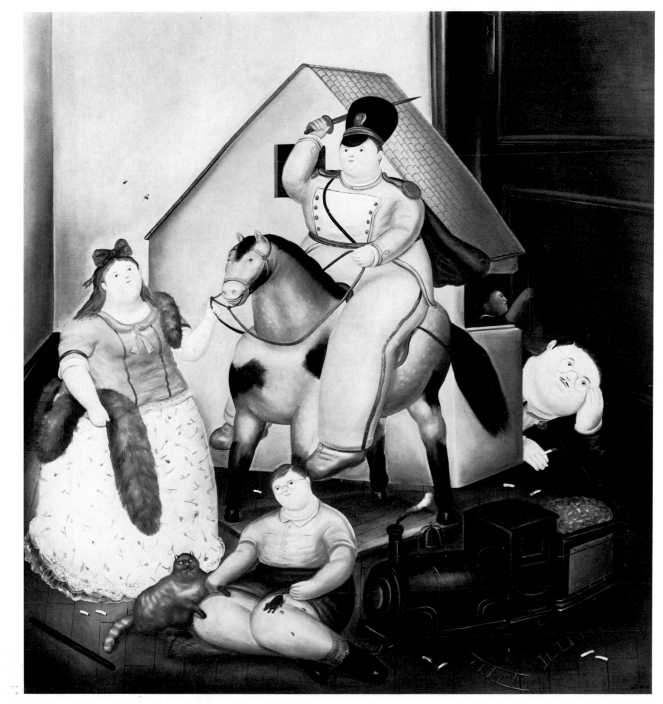

The playroom, 1970

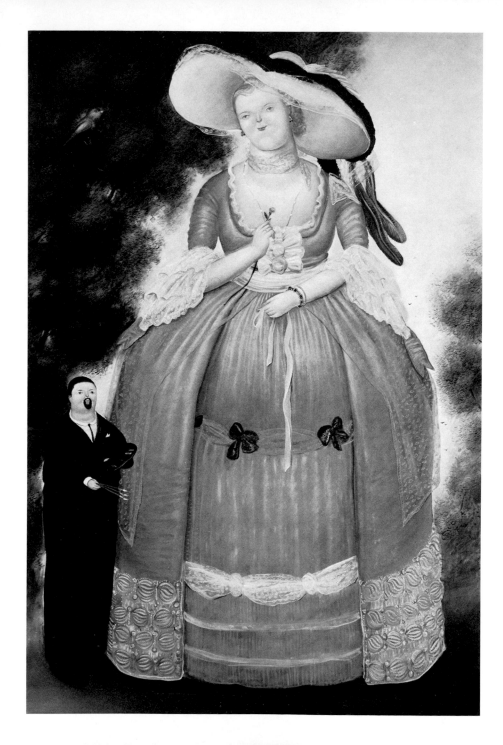

Self-portrait with Madame Pompadour, 1969

Artist minus easel

Many of Botero's friends admire his *peinture*, the beautifully executed surfaces and rich detail of his paintings. Though his elephantine subjects may disturb them, they are generally appeased by his painterly culture, something that is becoming increasingly rare among young artists.

The critics, on the other hand, find Botero's perfection particularly unpleasant, saying that it heightens the presence of his figures to the point of caricature. Anyone who works in so illustrative and eclectic a manner, they assert, must owe his success to his craftsmanship (nowadays almost synonymous with corruption).

Like so many opinions about Botero's art, this is one-sided in its attempt to separate content from means of expression. The way he goes about making a painting is quite different from that still generally taught at art schools today. The little academic schooling he did have was not particularly useful to him. He preferred the halls of the Prado to the tradition-steeped classrooms of the Academia San Fernando, where Picasso and Dali once had studied. His most exciting and demanding teachers were Velasquez and Goya, who set him tasks through the example of their own paintings.

This confrontation with old masters was his problem from the beginning, and for him it provided the really interesting, challenging, and indispensable course. He is still working at it, for he feels that long and painstaking study of the masterpieces of world art is the only hope for painting.

This conventional and seemingly academic approach is in sharp contrast to his actual painting procedure. Whether you praise or criticize their treatment, hardly any of his paintings were done on an easel. You will look in vain for this time-honoured implement in Botero's studio. The painter whose compendious knowledge and traditional technique disqualify him as a modern in some eyes, paints his pictures on the wall. That is to say on canvas attached to the wall, and—likewise conservative—not in acrylics but in oils. Not until the painting is

finished does he take it down, trim it to size, and fasten it to the stretchers. He tacks the larger canvases to flat boards before beginning work, because this allows them to be raised and lowered at will.

All this may seem beside the point or even trivial, but things start getting interesting when Botero explains that he leaves the final 'cropping' of his paintings to the very last. For him the painting surface is not a rectangle of predetermined size, but a plane with flexible proportions. It can be stretched out or narrowed down, depending on how the image develops during the process of painting as little by little figure and ground begin to interact and create tension on the plane.

This open-ended method not only gives Botero a certain degree of freedom in making corrections which, on a normal fixed canvas, can only be made by altering the contours of the subject; more important is the opportunity it offers to develop and accentuate the plastic qualities of the image against the plane of the wall, and to treat it during the final stages almost as if it were a sculpture.

The character of Botero's painting is really inseparable from this technique of 'painting on the wall'. It becomes clear when we remember that the usual easel painting is mobile—it can be freely moved around the studio during the course of painting and is unaffected by changing light conditions or studio space. Botero's wall-paintings, in contrast, develop literally in opposition to the studio area: they are as immovable as frescoes. They exist in an unvarying state of tension in relation to the surrounding space, and impose their own three-dimensional quality upon it even though they are stretched out paper-thin on the plane of the wall. This may explain why their structure is so stable, and always clearly defined in spatial and plastic terms. It may also explain why Botero, after the problem of proportion, is most fascinated by that of perspective—perspective as a face-to-face experience of space.

When one speaks about Botero being a 'copyist', the thought occurs that he seems to have no use for that prime instrument of the copyist's trade—the easel. The reason for this is simple: he is not interested in making mere copies. After such thorough observation of great works of art, he has digested them so completely that he can project them through the medium of his vision on to canvas. The transformation does not take place in his wrist or his fingers, but in his head, and in the space between the walls of his studio.

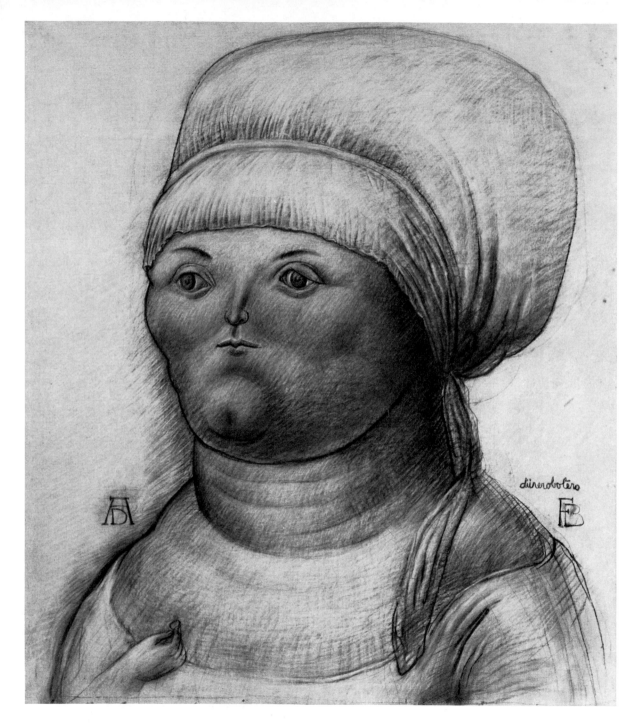

Elisabeth Tucher, 1968

Dürerobotero

Masterpieces from the great museums of the world figure in Botero's procession like the votive images of religion. Again and again he returns to the treasures of European art. A portrait of Rubens's wife has served him as a model four separate times. And he has also painted them both, the Flemish master and Isabella Brant, under the honeysuckle trees.

All of these paraphrases of Dürer and Rubens, of Caravaggio, Cézanne and Bonnard, are gestures of respect like those Picasso never tired of making to Velasquez and Manet, a way of making paintings that, far from having any parodistic intent, has always been and will always be part of the dialogue between artists present and artists past. Botero discovers affinities in Dürer's drawing style; he does all of his portraits in the Dürer manner in charcoal on canvas (page 34). He is fascinated by the sheer corporeality of Rubens's nudes, and by their sensuous colour. Later he develops an interest in eighteenth-century modes: the light, transparent tones of Rococo painting, the ornamental texture of a Gobelin tapestry.

Bonnard's backlit nudes may suddenly find themselves on spacious beds or in tiled showers (page 37), milieus perhaps more vulgar than their originals, but with a painterly delicacy of surface that rivals them in every way. The subject is secondary; the roundness of a juicy melon, its red flesh and green skin, are just as tantalizingly real as the nudes of Adam and Eve painted after old masters or the nakedness of the voluptuous female in the rural concert (page 60). Or, again in charcoal on canvas, after an eighteenth-century engraving, Botero will draw Louis XVI and his family in prison (page 48), their heads like buds, their bodies like exotic fruits: the feasters waiting to be feasted upon. Remember here that the 'edibility' of his subjects is always a metaphor for another kind of enjoyment that is more sublimated and at the same time more intimate, namely the primitive belief that by eating something or someone one can appropriate its reality for oneself.

On his choice of subjects Botero expends a great deal of careful thought. Apples, for instance, are the property of Cézanne, since it is Cézanne who has done the most masterful paintings of them. In his obsession with objects, Botero only borrowed them from him for a while. For a long time they appeared among the other varieties of fruit in his still-lifes, then he decided to stop using them. His argument was both rigorous and personal: 'I'm not going to paint apples any more. Oranges and bananas are the most common fruits in the tropics. There, apples are only for snobs.'

Yet Botero enjoys fruit provided by others. He sits down at well-stocked tables. His mystic meal with Dürer seals the signature that we find not only on the portraits of Elisabeth Tucher (page 34) and Oswolt Krel, but also on the portrait painted after Dürer's self-portrait—'dürerobotero'. This is brotherhood among artists and not the false modesty of the copyist, which is usually expressed in the formula 'Botero, after Dürer'.

In 1972 he had dinner with Piero della Francesca and Ingres (page 39). Not as a self-effacing artist who hangs his likeness in a corner or in the background as a mute witness to the scene, but sitting quite confidently at the table, an equal among equals, a colleague among colleagues. This dinner party also has its ritual aspect, with Ingres dominating in strict frontality, a master of ceremonies not only of table but of painting. Piero and Botero, by contrast, look as if they have just interrupted their friendly conversation for a moment, their dinner at an end. A door ajar and the maid approaching with her tray serve to open up the intimate scene for the outsider, establishing a link with the viewer's time and space, and reveal the clue to the allegory hidden in this figuration: the tiny lamp shining above Ingres's head—the Holy Trinity of art.

This insistence on Botero's part of being put on a plane with his peers must be seen as a purposeful challenge to all those in Europe and North America who persist in seeing things with European blinkers. This painter from

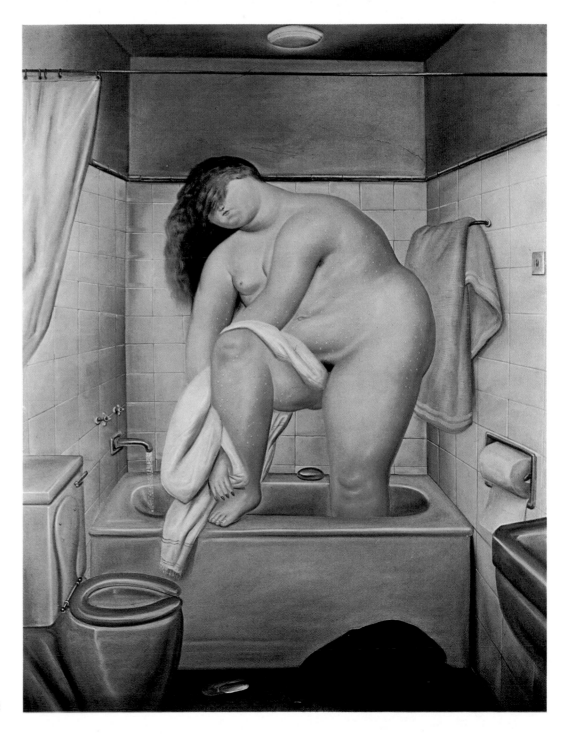

Homage to Bonnard, 1972

Latin America is not interested in following in the footsteps of his German, Spanish, Dutch or French 'ancestors'. For him painting is neither a process of adaptation nor emancipation. Rather, he asserts himself to be one of them, a contemporary in more than one sense of the word, by thinking of time as a continuum, by consciously wishing to share his period with other artists, by demanding his right to their partnership—and his right to enjoy it. It is the heir to a long, unhappy history who is making this demand, and it is not a pleasant one either for us or for him. This is a lesson for our time the equal of which would be hard to find. Botero is the opposite of the outsider many have felt him to be. He is an insider in the true sense, and being this, he holds up a mirror to what is and to what has been.

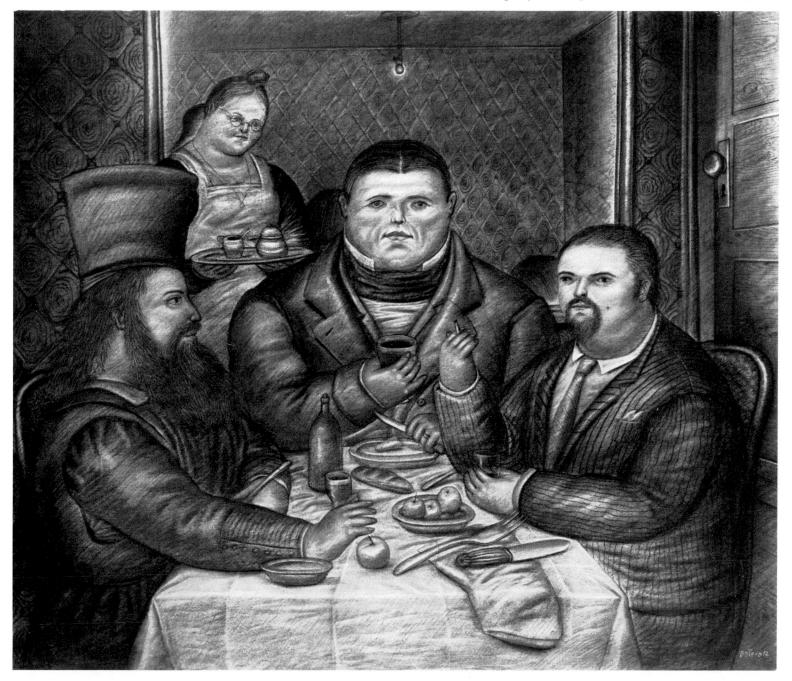

Pages 41–48:

41 Girl eating icecream, 1970
42 A family with Colombian pets, 1970
43 The servant-girl, 1970
44 Still-life, 1972
45 Still-life with hot coffee, 1972
46 Eva, 1972
47 Portrait of Cecilia and Pedro, 1974
48 Louis XVI and his family in prison according to an old etching, 1968

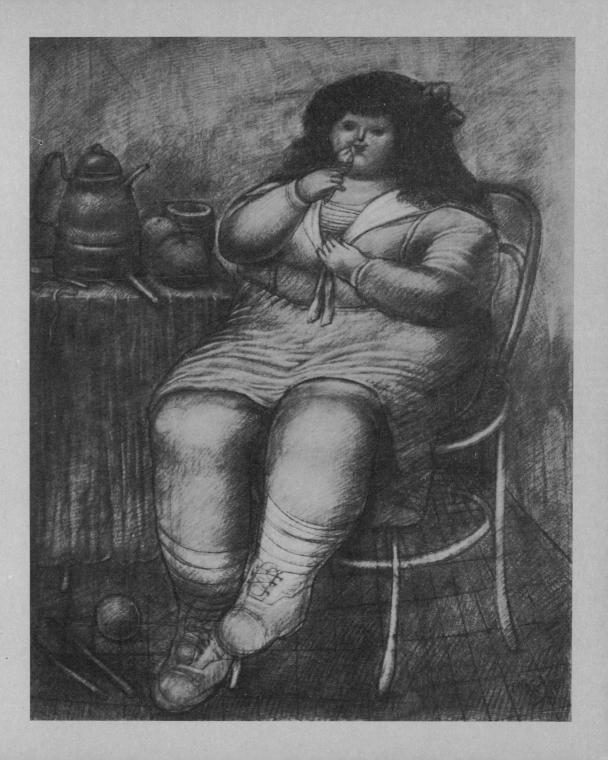

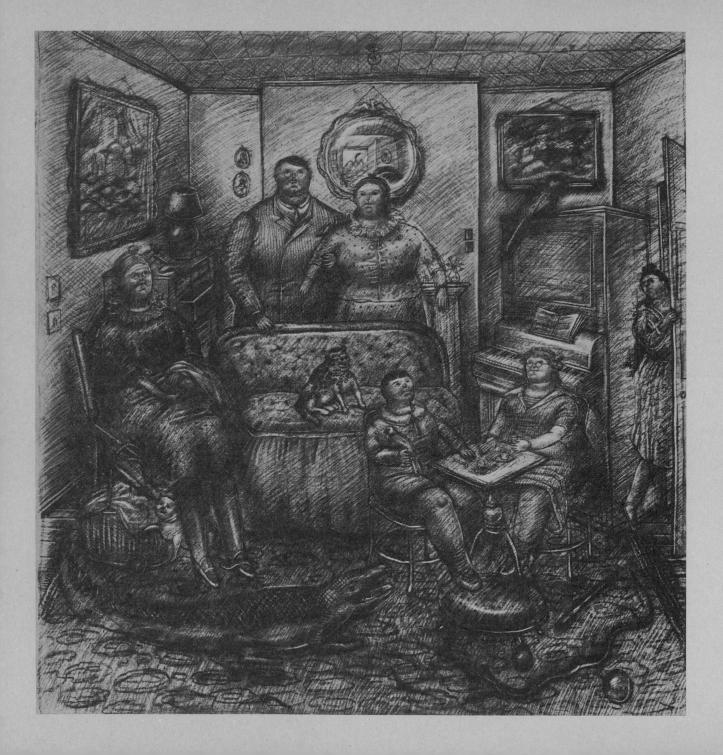

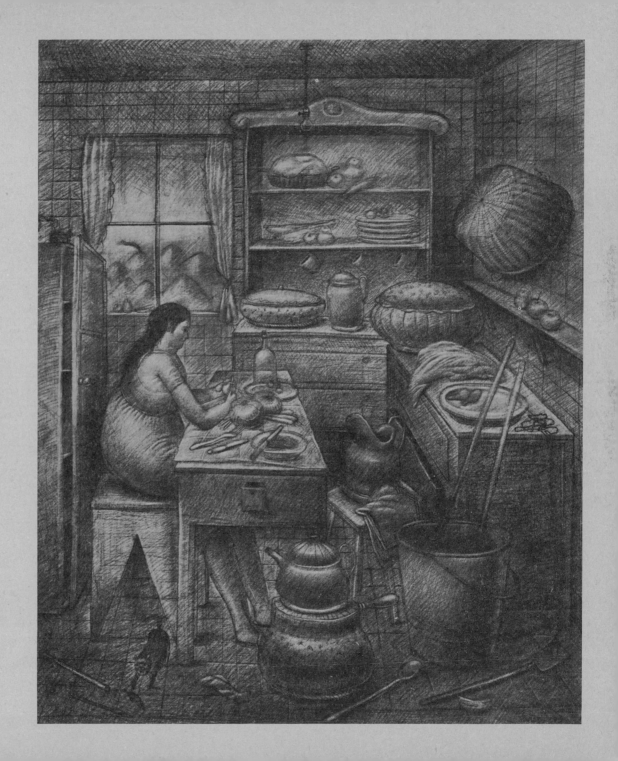

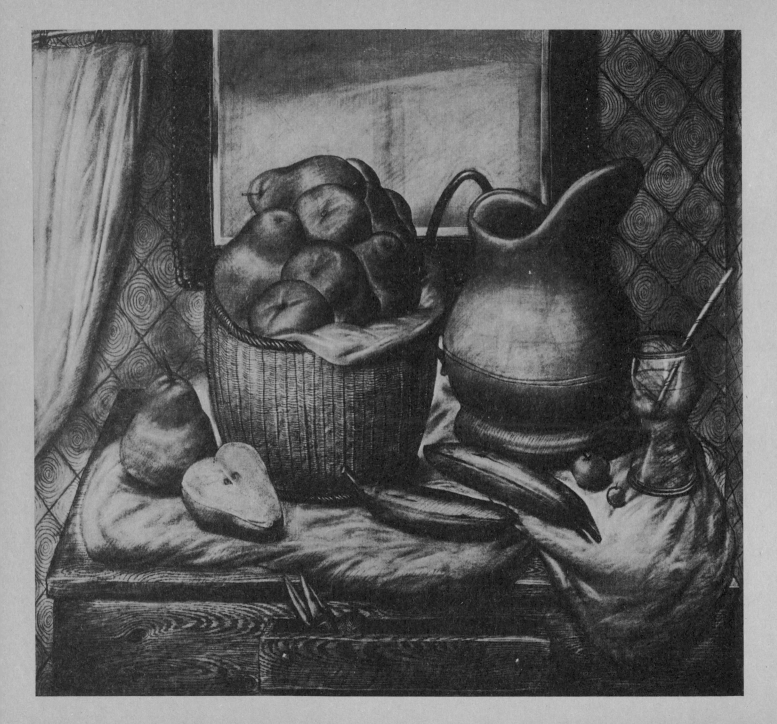

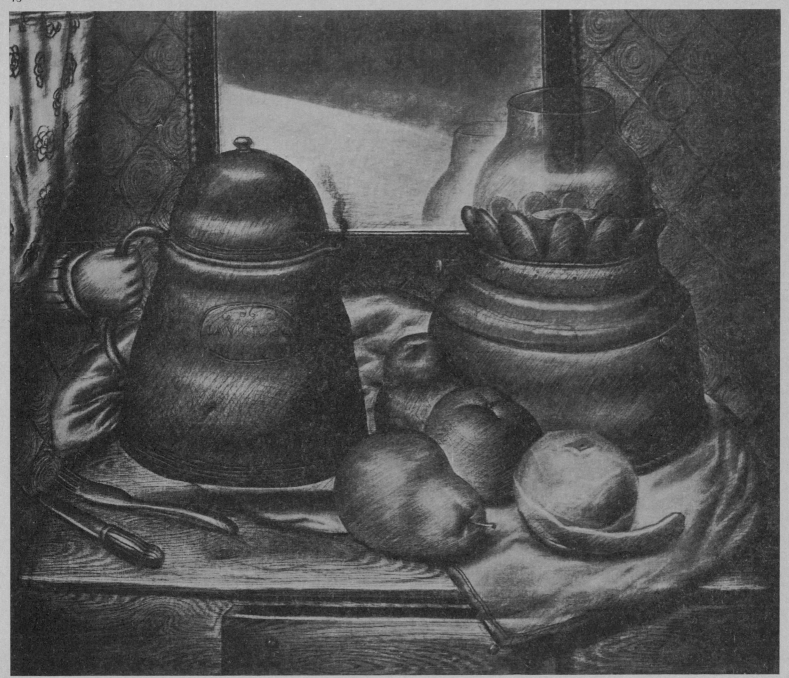

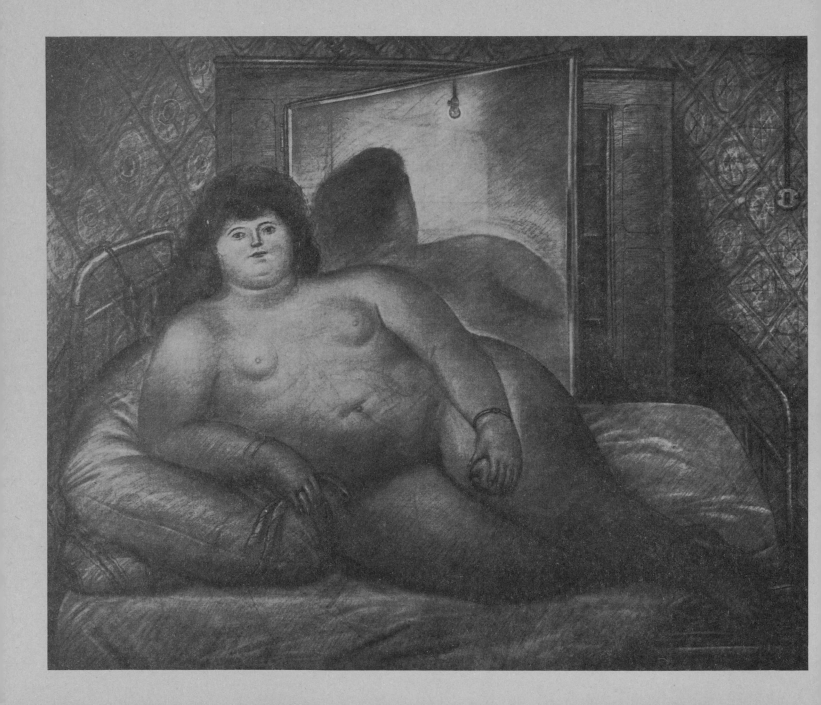

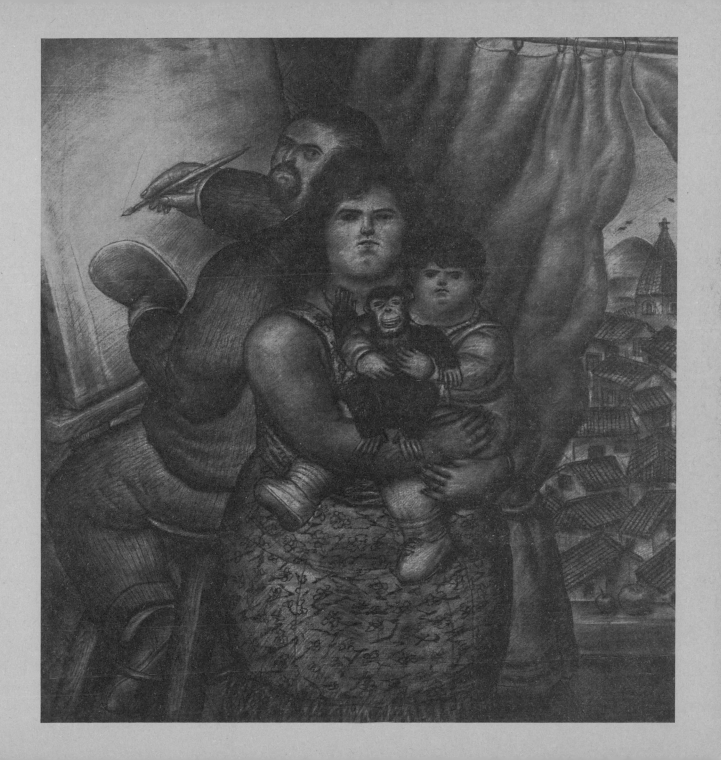

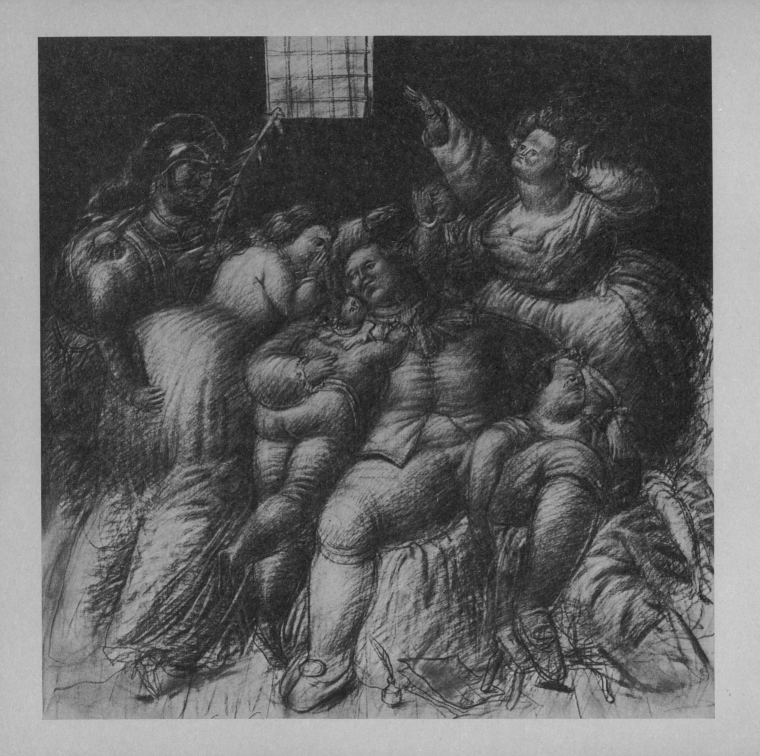

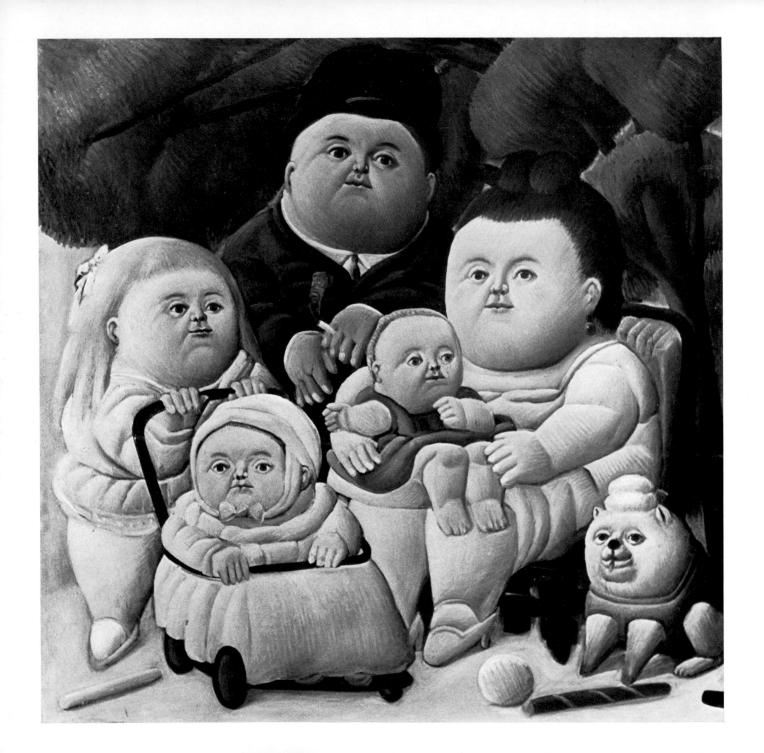

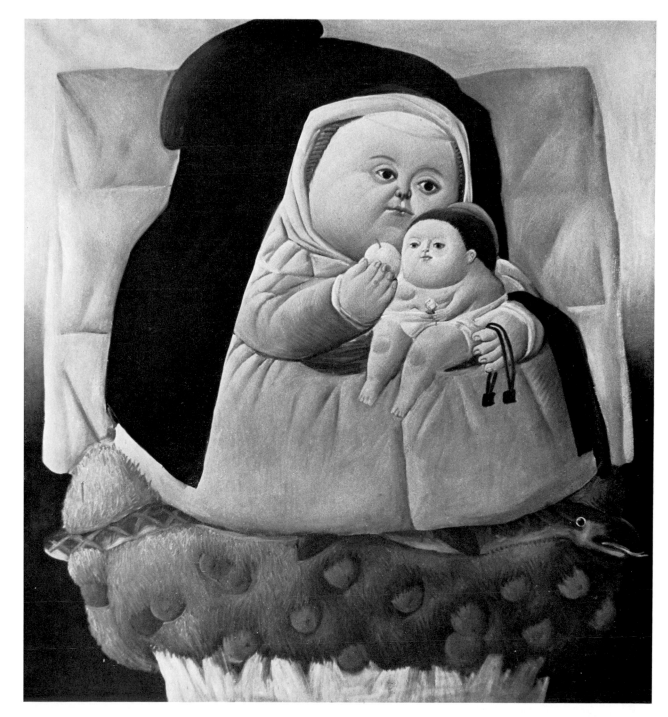

51

The Pinzón family,
1965

Madonna and Child,
1965

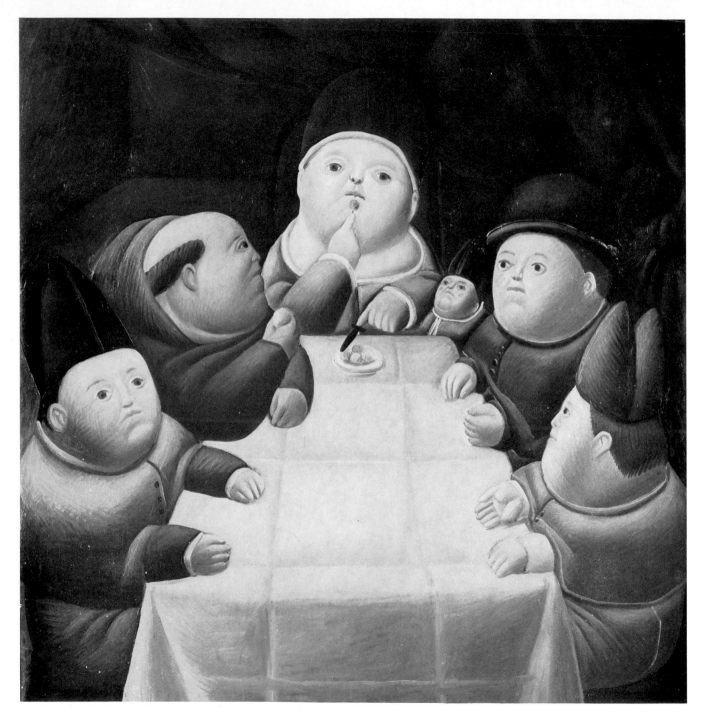

The supper,
1966

The rich
children,
1966

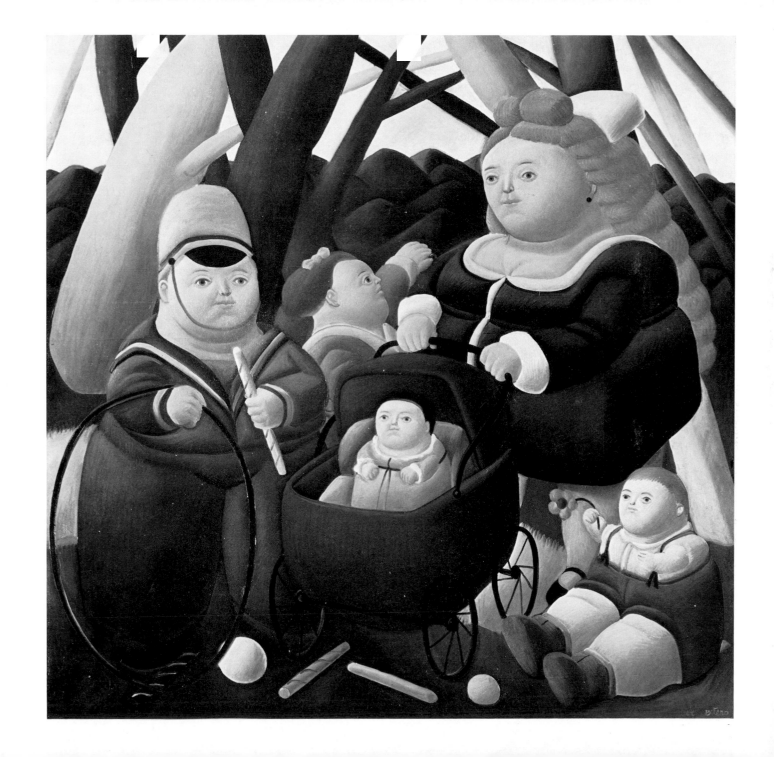

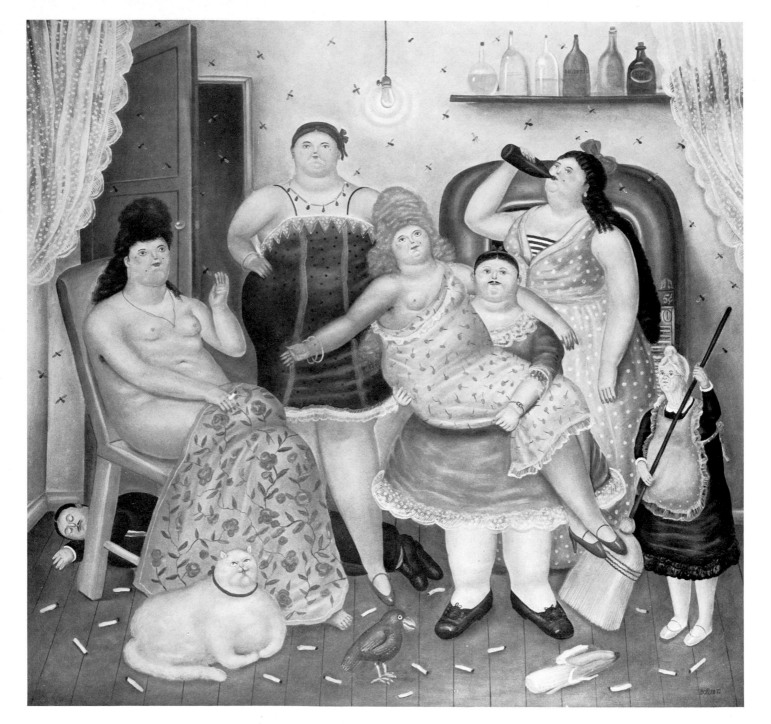

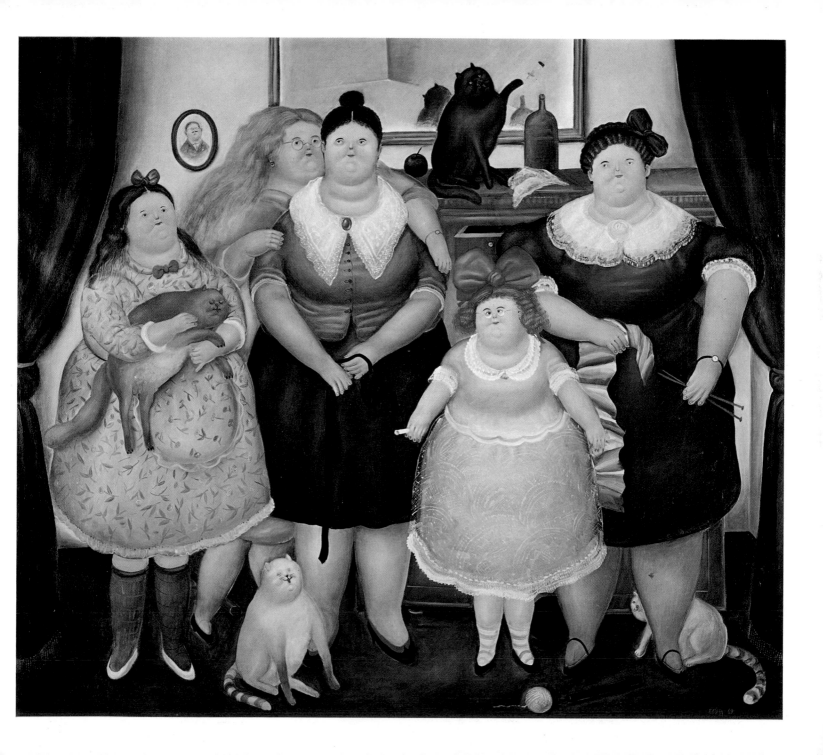

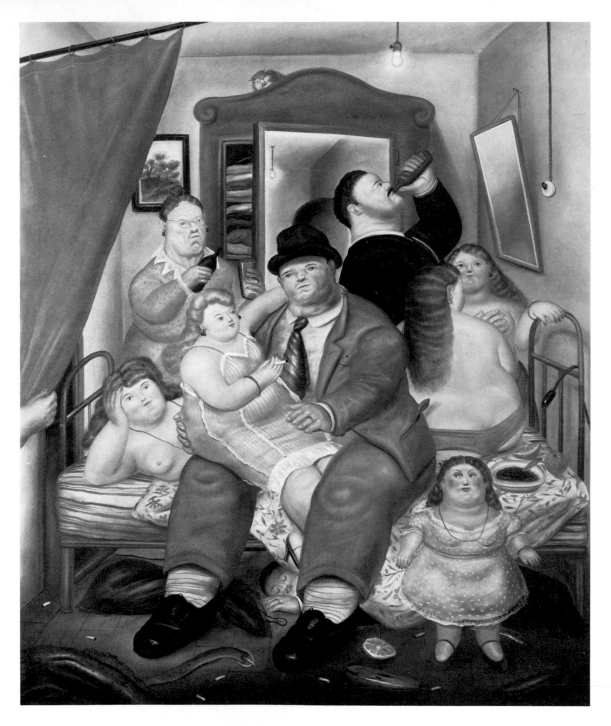

Page 54:
House of Mariaduque, 1970

Page 55:
The sisters, 1959

House of the Arias twins,
1973

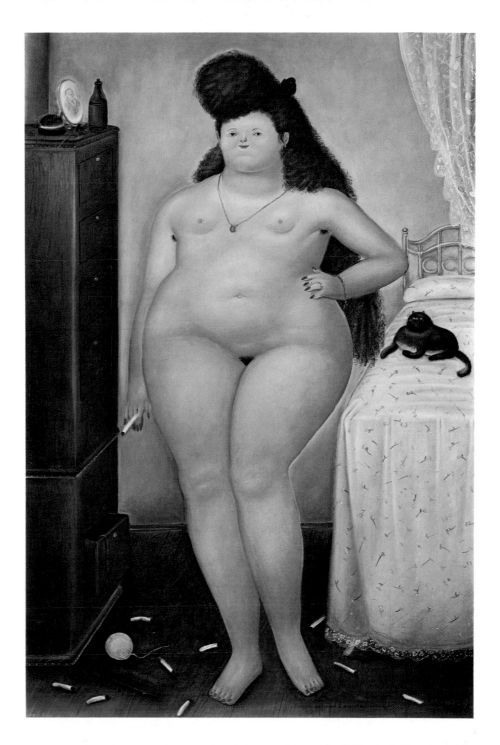

Rosalba, 1969

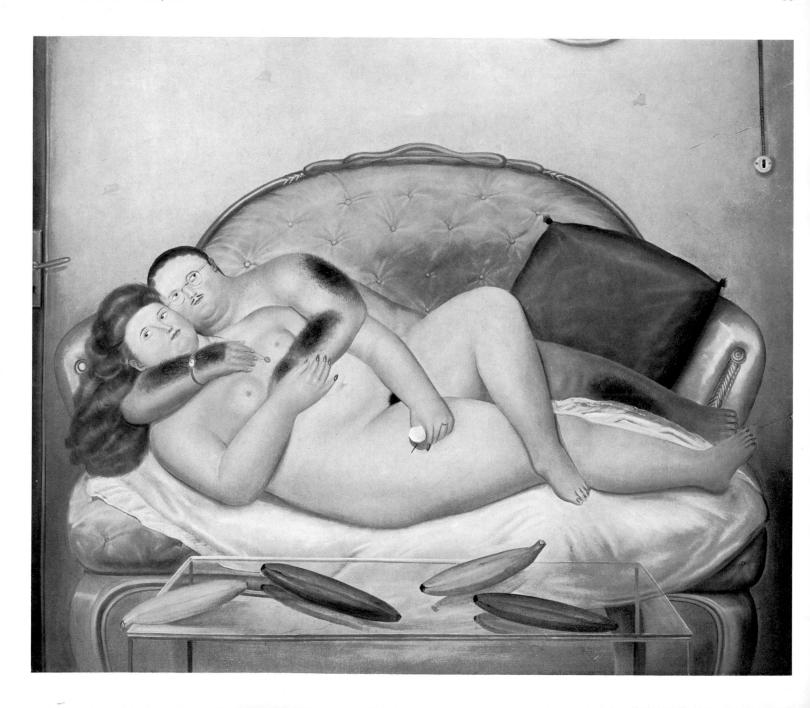

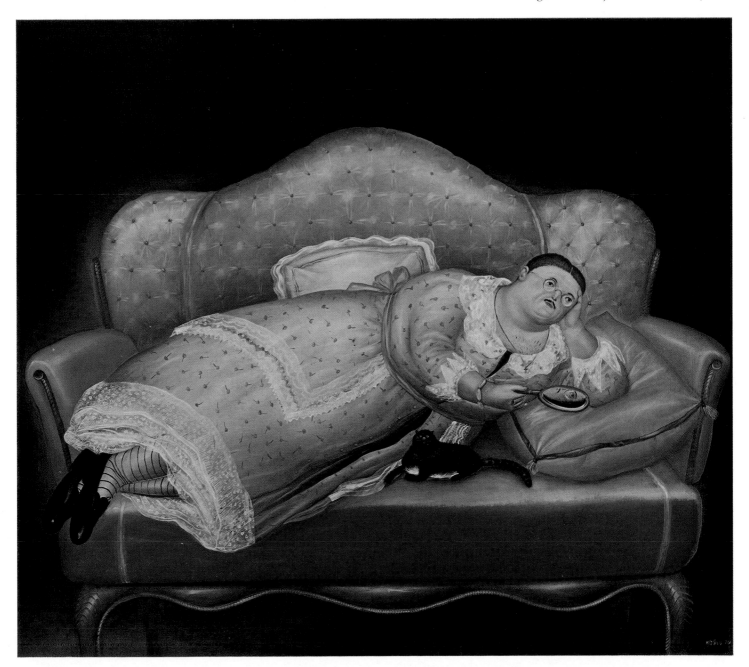

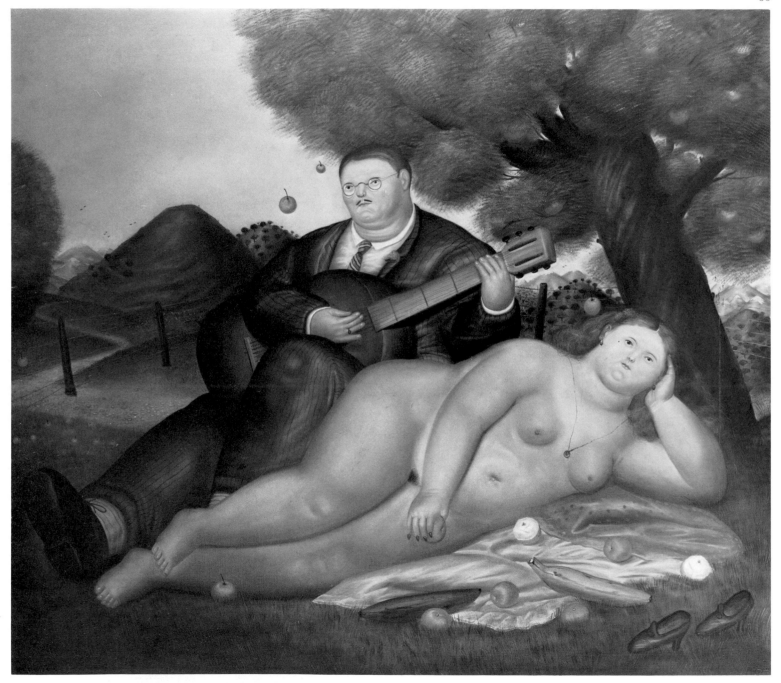

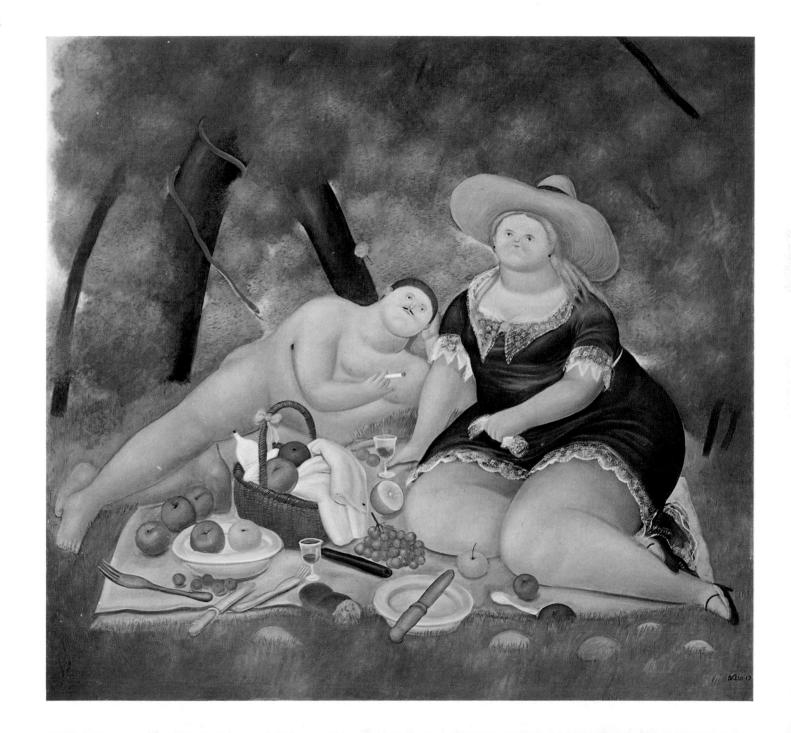

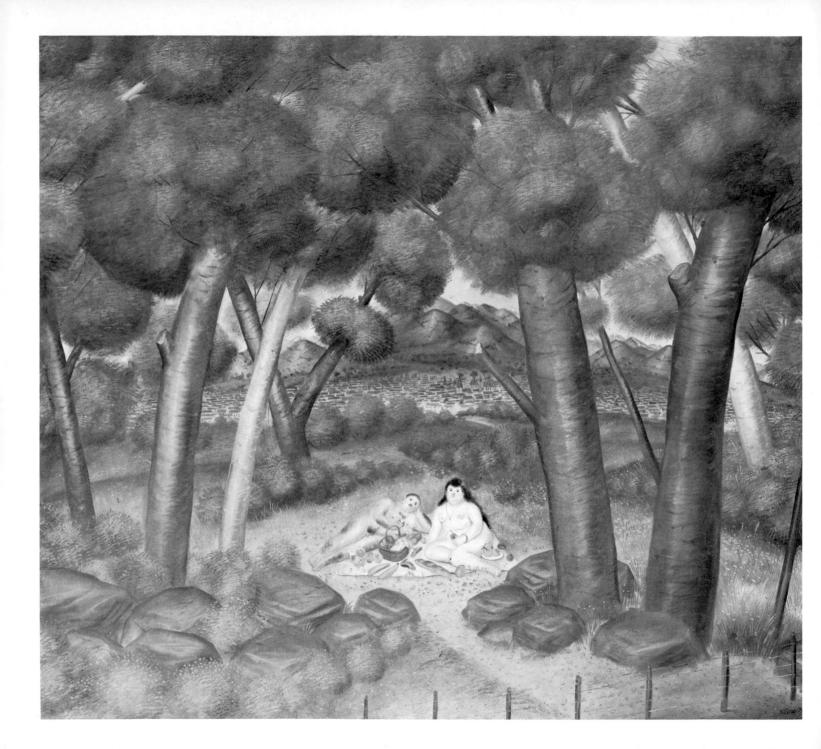

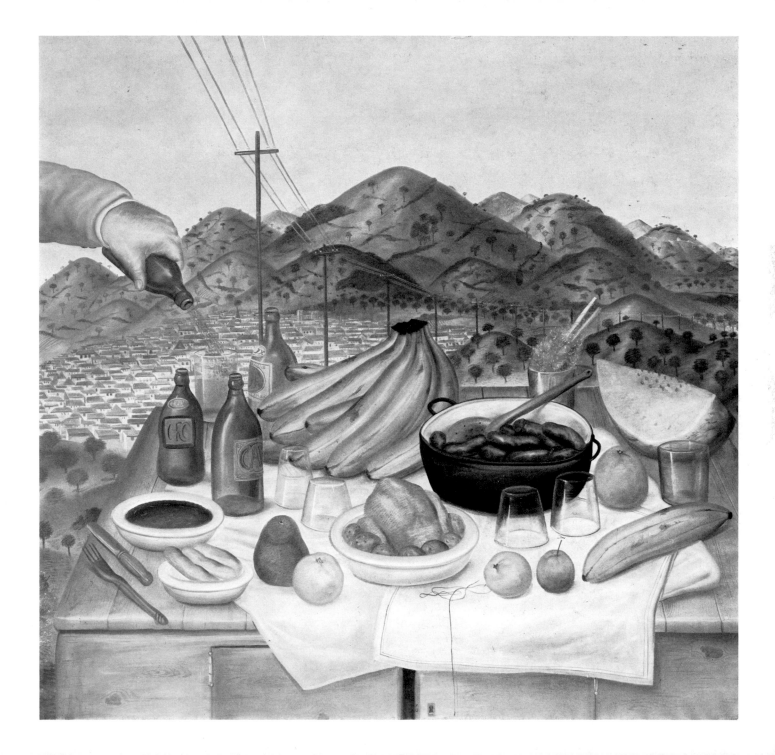

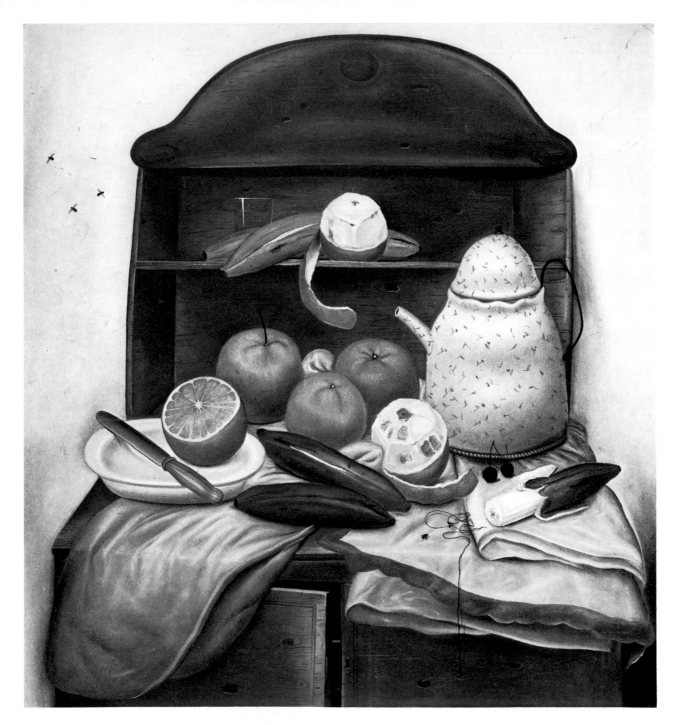

Page 62:
Picnic, 1973

Page 63:
Colombian
still-life, 1973

Chest still-life,
1970

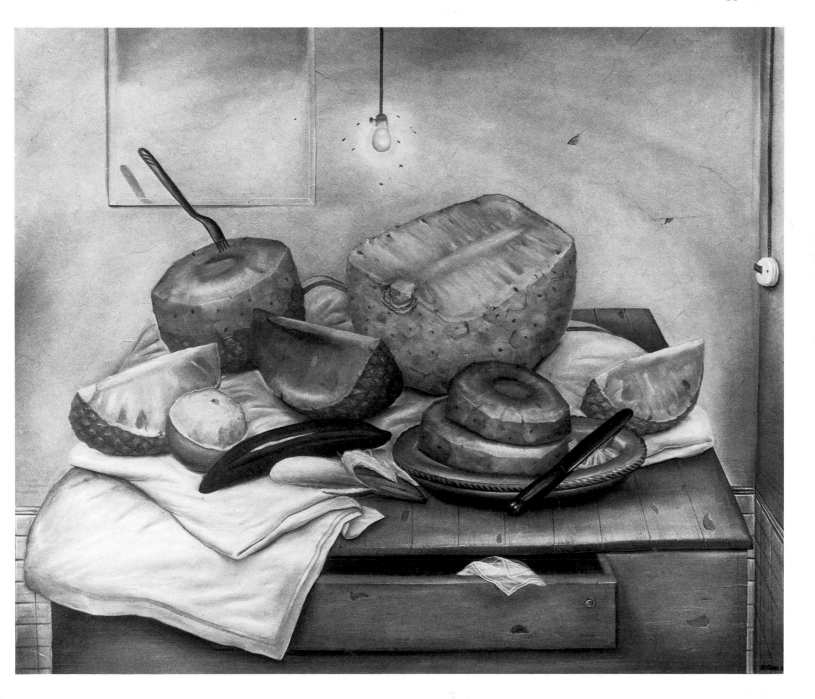

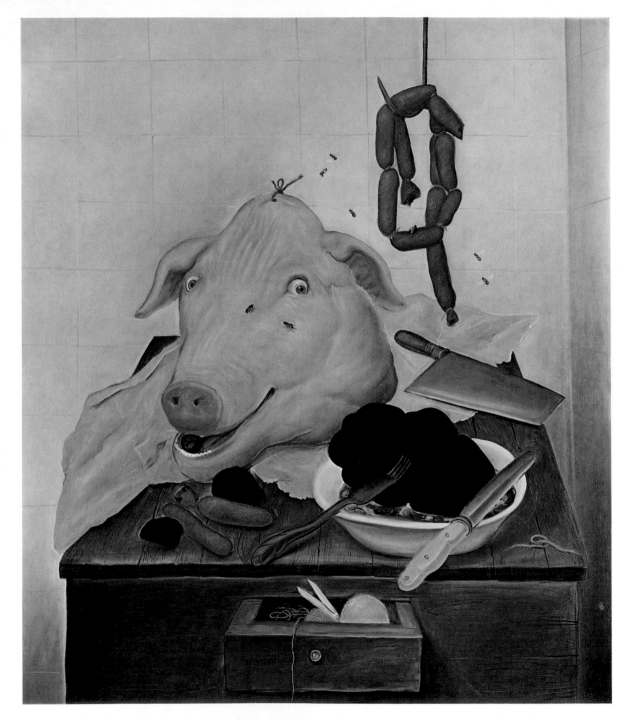

The butcher's table, 1969

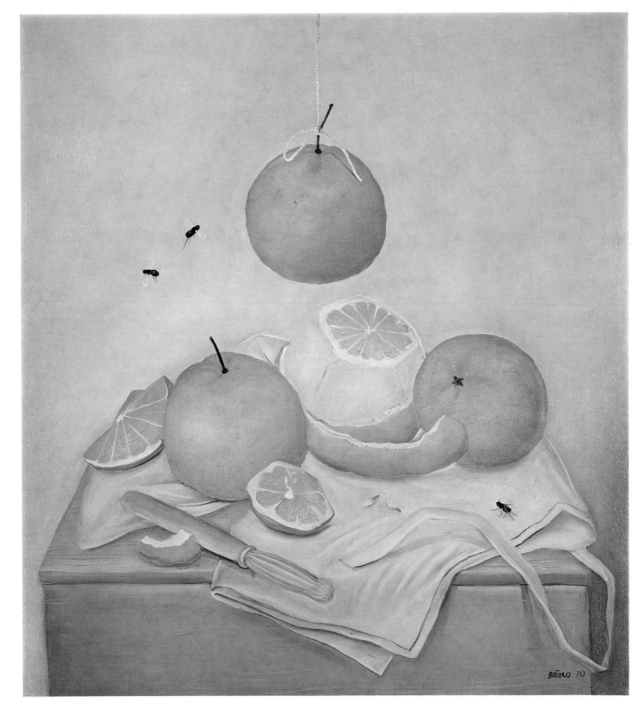

Oranges, 1970

Page 68:
Homage to Sanchez
Cotan, 1972

Page 69:
Boy eating water-melon,
1972

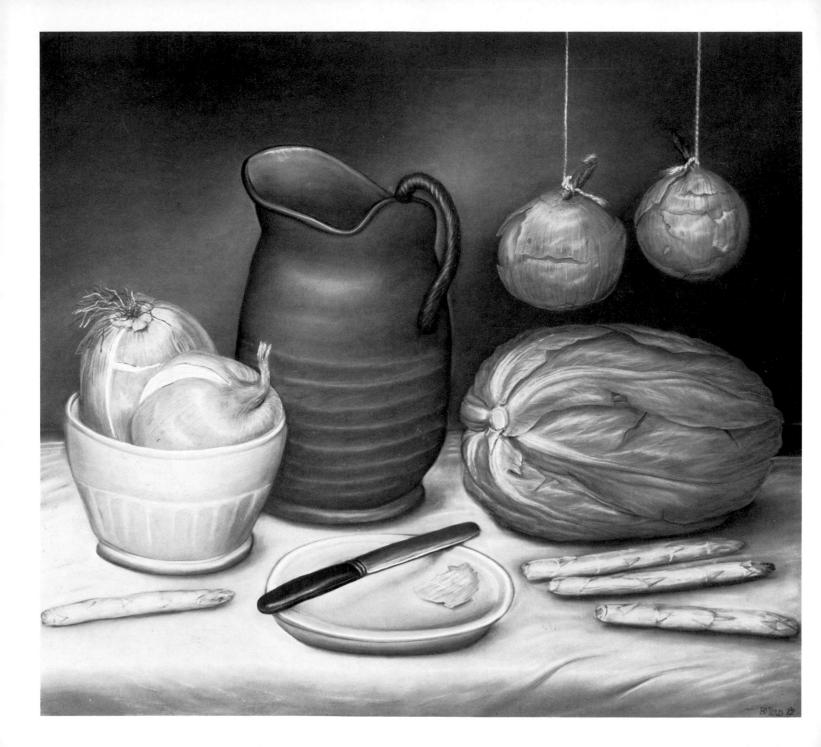

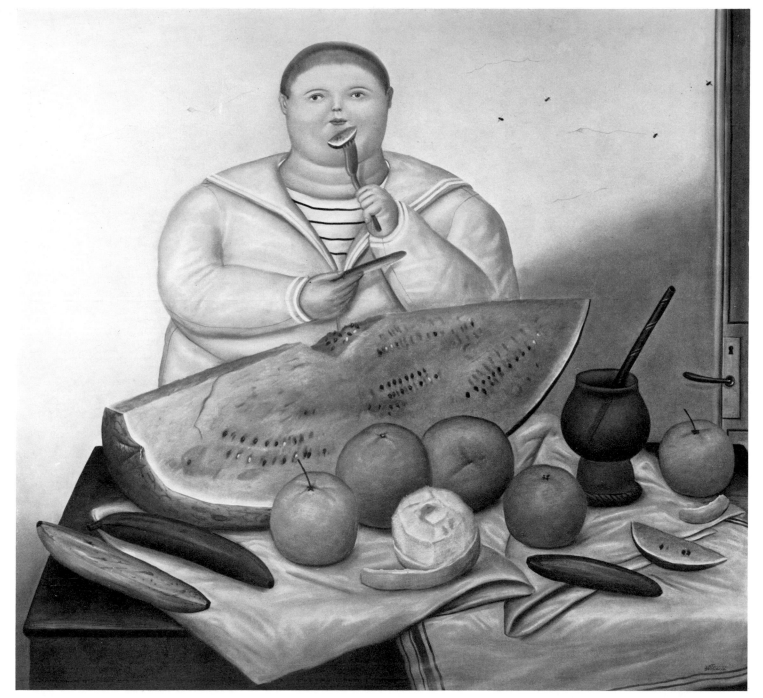

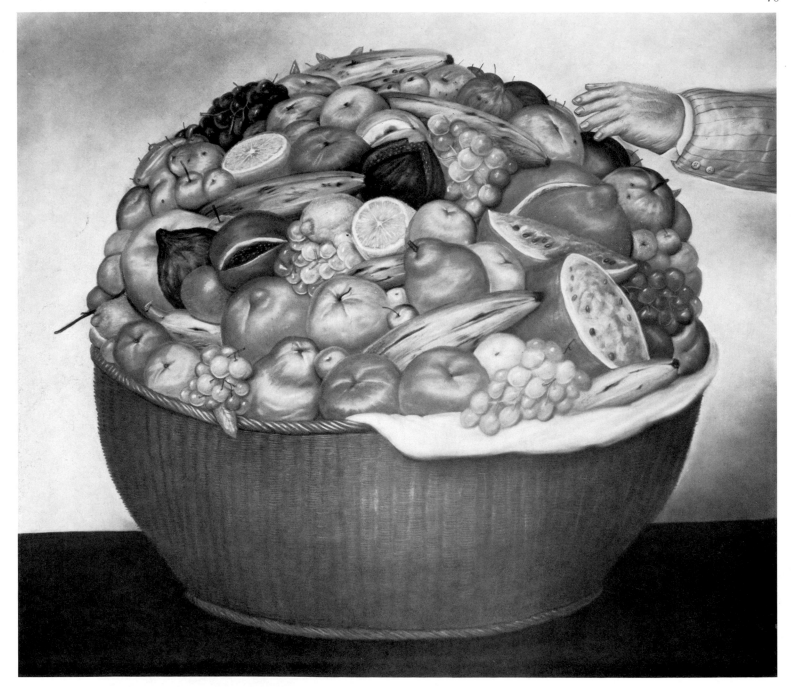

71

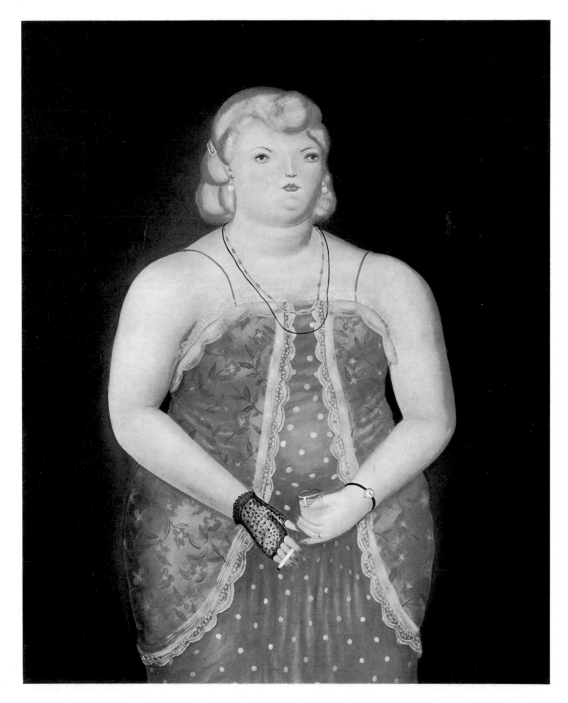

Fruit-basket, 1972 Maruja, 1970

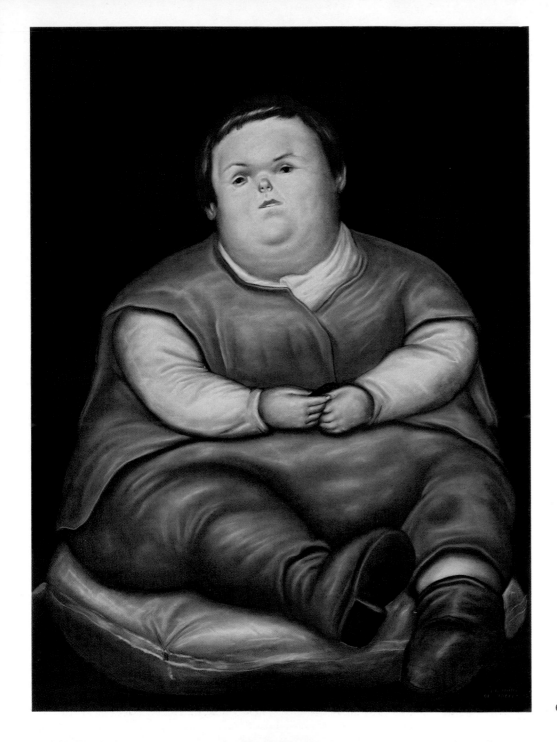

Child from Vallecas, after Velasquez, 1971

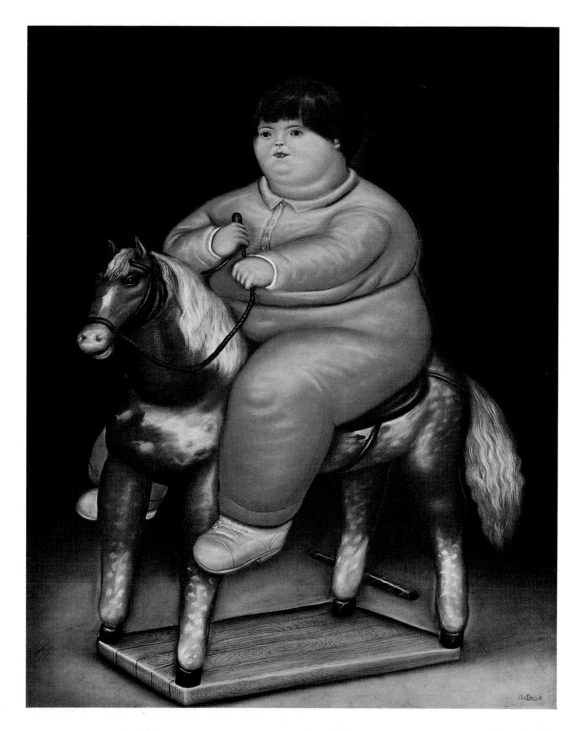

Pedro with rocking-horse, 1971

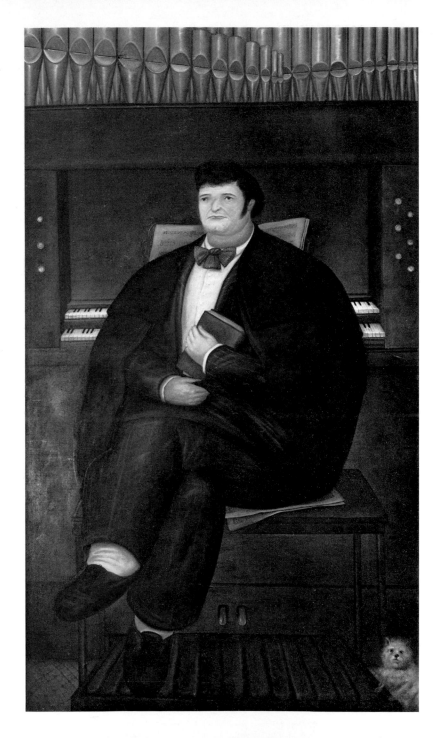

Portrait of Claude Bernard, 1972

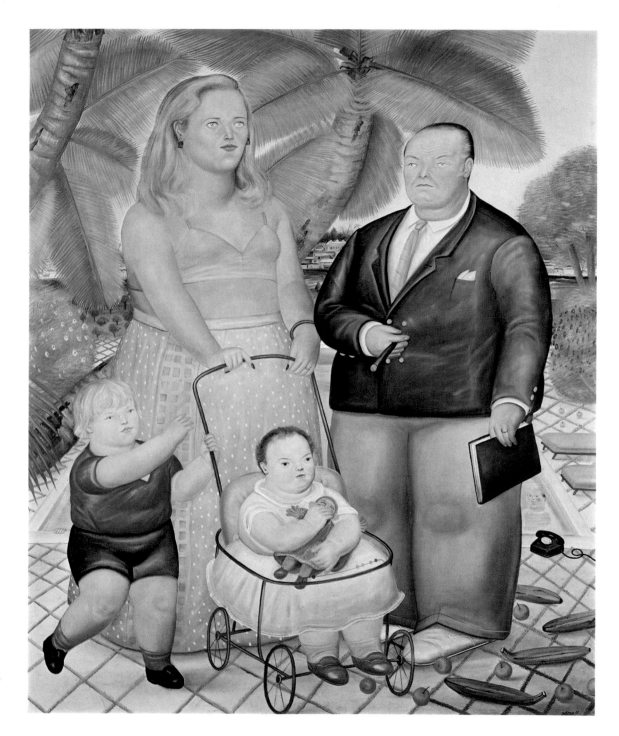

Mr. Frank Lloyd and his
family in Paradise Island,
1972

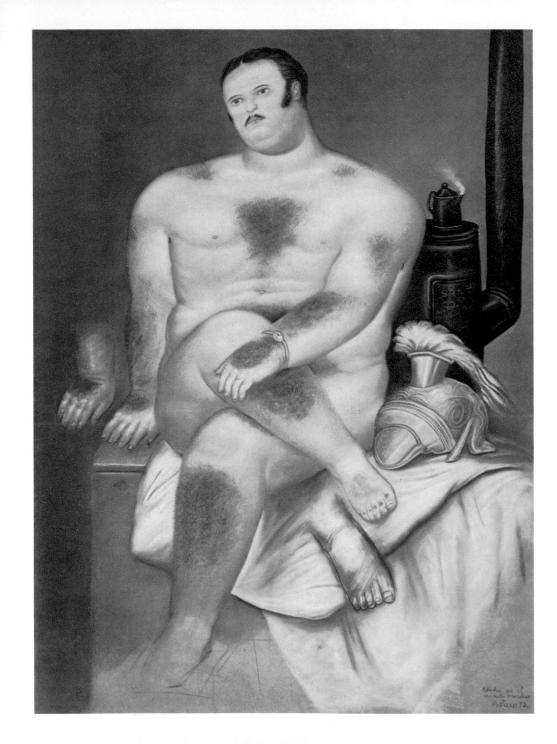

Study with the male model, 1972

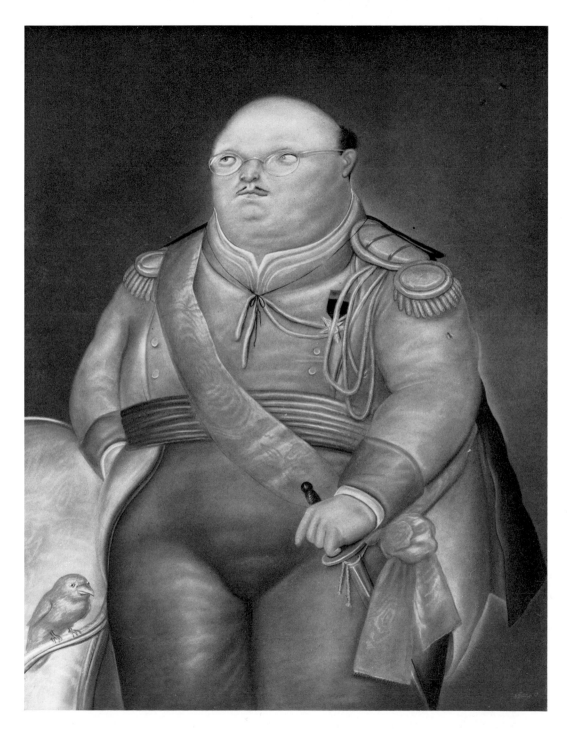

Minister of War, 1973

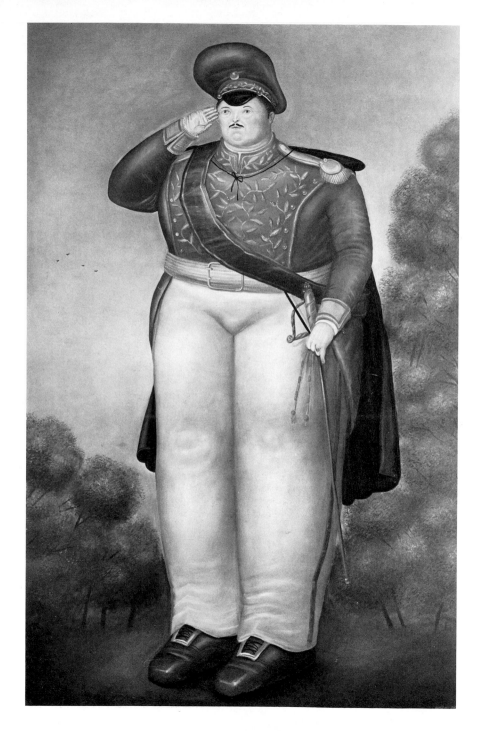

Field Marshal, 1970

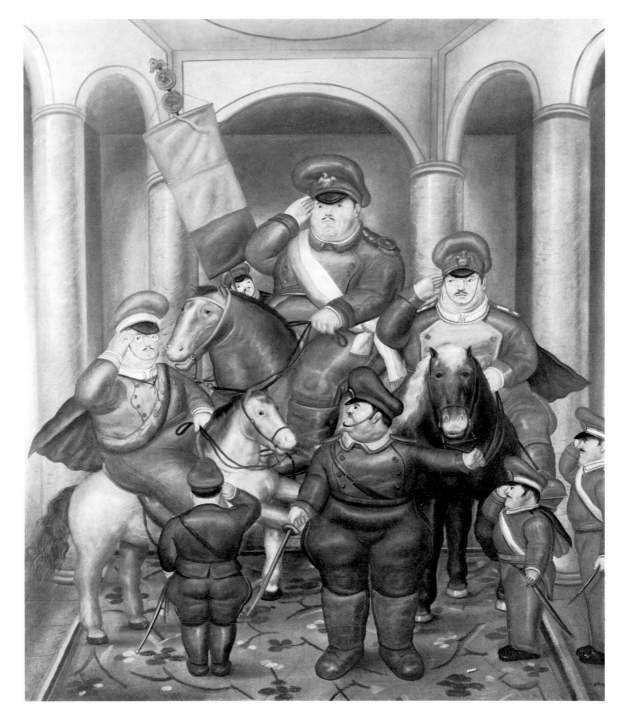

Military Junta, 1973

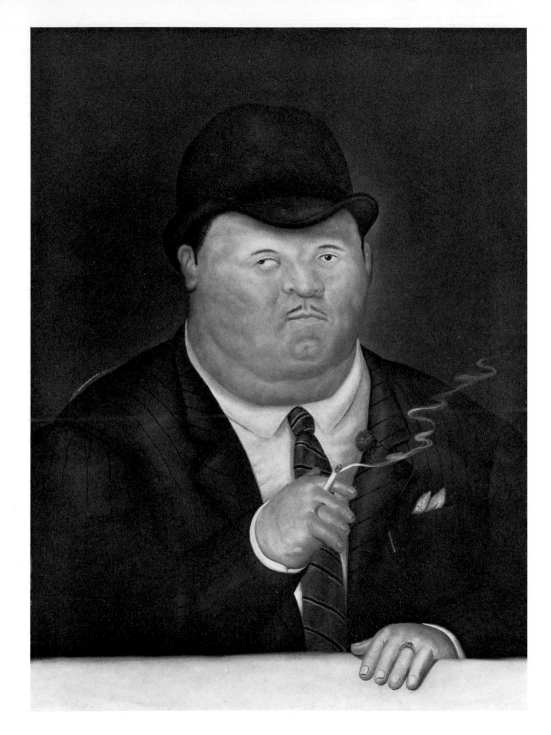

Man smoking, 1973

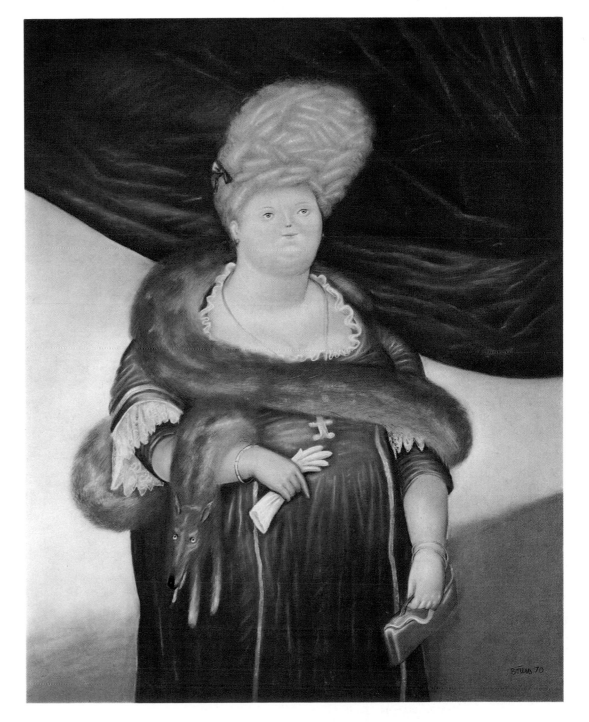

The First Lady, 1970

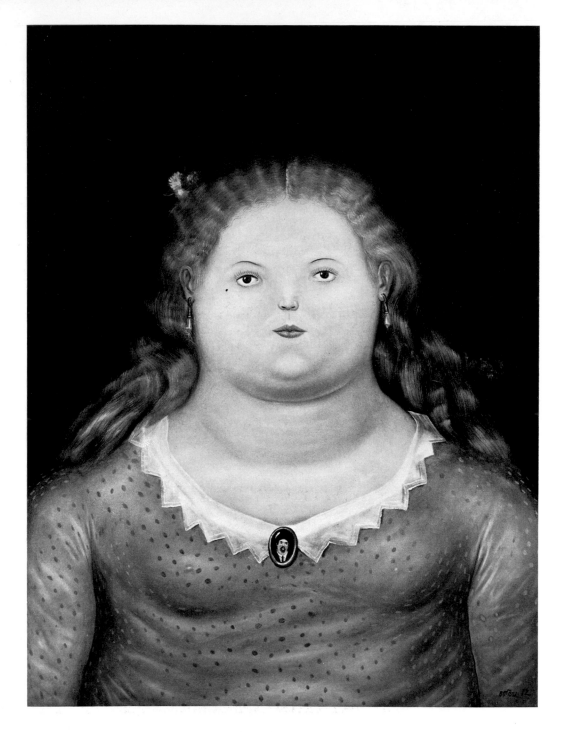

Delfina, 1972

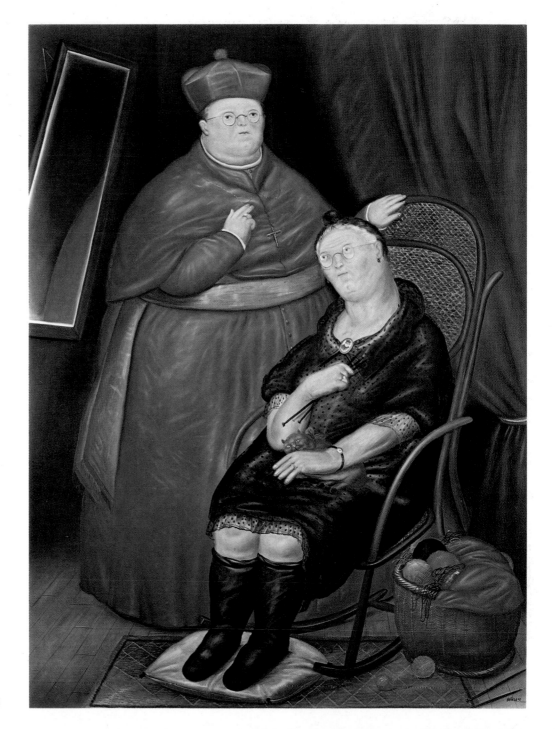

The mother of the Cardinal, 1972

1932	Fernando Botero born in Medellín, Colombia.
1948	Shows for the first time in a group exhibition in his home town.
1950	Visits Bogotá and its art museum; up to then he had seen contemporary art only in reproduction.
1951	Settles in Bogotá. First one-man show at the Leo Matiz Gallery, Bogotá.
1952	Second and more successful one-man show in Bogotá, enabling him to finance a trip to Europe. Receives Second National Prize for Painting in Colombia. Travels to Spain. Studies in Madrid at the Academia de Bellas Artes de San Fernando and, in the Prado, the works of Velasquez, Rubens, Goya and Piero della Francesca. Attempts to earn a living by selling copies of Titian and Tintoretto paintings.
1953/54	Visits Paris, the Musée National de l'Art Moderne and the Louvre, where 17th century French painting interests him most. Journey through northern Italy to Tuscany, where he acquaints himself with Florentine painting of the Quattrocento, particularly Piero della Francesca, and fresco technique. Studies art history at the University of Florence under Roberto Longhi.
1955	Returns to Bogotá.
1956/57	Lives for a year in Mexico. Discovers the painting of José Clemente Orozco, David Alfaro Siqueiros, and Diego Rivera.
1957	Goes to Washington, where he has a one-man show in the Pan American Union.
1958/59	Works in Colombia; has several one-man shows.
1960	Moves to New York. Wins the Guggenheim National Prize for Colombia.
1961	The Museum of Modern Art purchases his painting *Mona Lisa at the age of twelve*, 1959.
1966	First European one-man show in the Staatliche Kunsthalle in Baden-Baden, Germany.
1967	Travels in Italy and Germany. Studies the work of Dürer, Cranach and Grünewald in Munich and Nuremberg.
1971–	Lives the greater part of the year in Paris with summers spent in Colombia.

Page

2 *Fernando Botero*, 1975

6 *The Presidential family*, 1967
Oil, 203 × 196 cm (80 × 77″). The Museum of Modern Art, New York

11 *Family scene*, 1969
Oil, 211 × 195.5 cm (83 × 77″). Collection Richard Zeisler, New York

12 *Family scene*, 1967
Oil, 187 × 178 cm (73¹/₂ × 70″). Collection Joachim Jean Aberbach, New York

13 *The President and the First Lady*, 1969
Oil, 267 × 135 cm (105 × 53″), Diptychon. Private collection, Germany

16 *Colombian still-life*, 1969
Oil, 196.5 × 195.5 cm (77¹/₂ × 77″). Collection Joachim Jean Aberbach, New York

19 *Our Lady of New York*, 1966
Oil, 196 × 180 cm (77 × 71″). Collection Paul S. Newman, New York

20 *Grandmother*, 1969
Oil, 185.5 × 124.5 cm (73 × 49″). Private collection, USA

23 *The War*, 1973
Oil, 191 × 279 cm (75 × 110″). Private collection, New York

26 *Man going to his office*, 1969
Oil, 188 × 188 cm (74 × 74″). Collection Harold Reed, New York

29 *The playroom*, 1970
Oil, 206 × 188 cm (81¹/₂ × 74″). Collection Joachim Jean Aberbach, New York

30 *Self-portrait with Madame Pompadour*, 1969
Oil, 245.5 × 166.5 cm (96¹/₂ × 65¹/₂″). Collection Joachim Jean Aberbach, New York

34 *Elisabeth Tucher*, 1968
Charcoal, 197 × 169 cm (77¹/₂ × 66¹/₂″). Kunsthalle, Nuremberg

37 *Homage to Bonnard*, 1972
Oil, 234 × 178 cm (92 × 70″). Aberbach Fine Art, New York

39 *The dinner party with Ingres and Piero della Francesca*, 1972
Charcoal, 163 × 189 cm (64 × 74¹/₂″). Aberbach Fine Art, New York

41 *Girl eating icecream*, 1970
Charcoal, 236×181.5 cm (93×71¹/₂″). Private collection, Germany

42 *A family with Colombian pets*, 1970
Charcoal, 188×180 cm (74×71″). Private collection, New York

43 *The servant-girl*, 1970
Charcoal and pastel, 251.5×195.5 cm (99×77″). Private collection, Germany

44 *Still-life*, 1972
Charcoal, 169×179 cm (66¹/₂×70¹/₂″). Private collection, Paris

45 *Still-life with hot coffee*, 1972
Charcoal, 167×189 cm (65³/₄×74¹/₂″). Collection Hanoj Pérez, Bogotá, Colombia

46 *Eva*, 1972
Charcoal, 157.5×190.5 cm (62×75″). Collection Stan Westreich, Washington, D.C.

47 *Portrait of Cecilia and Pedro*, 1974
Charcoal, 190.5×170 cm (75×67″). Collection Cecilia Botero, Bogotá, Colombia

48 *Louis XVI and his family in prison according to an old etching*, 1968
Charcoal, 189×185 cm (74¹/₂×73″). Aberbach Fine Art, New York

50 *The Pinzón family*, 1965
Oil, 170×170 cm (68×68″). The Museum of the Rhode Island School of Design, Providence, R.I.

51 *Madonna and Child*, 1965
Oil, 187×165 cm (73¹/₂×65″). Collection Hart Perry, New York

52 *The supper*, 1966
Oil, 198×193 cm (78×76″). Milwaukee Art Center

53 *The rich children*, 1966
Oil, 198×193 cm (78×76″). Aberbach Fine Art, New York

54 *House of Mariaduque*, 1970
Oil, 180×185.5 cm (71×73″). Collection Joachim Jean Aberbach, New York

55 *The sisters*, 1959
Oil, 194.5×218 cm (76¹/₂×86″). Collection Julian Jean Aberbach, Paris

56 *House of the Arias twins*, 1973
Oil, 227×187 cm (89¹/₂×73¹/₂″). Collection Harry N. Abrams, New York

57 *Rosalba*, 1969
Oil, 193×126 cm (76×49¹/₂″). Aberbach Fine Art, New York

58 *Lovers on a French sofa*, 1972
Oil, 165×196 cm (65×77″). Private collection, Rome

59 *The melancholy transvestite*, 1970
Oil, 175×195.5 cm (69×77″). Collection Julio Mario Santodomingo, Bogotá, Colombia

60 *Rural concert*, 1972
Oil, 166.5×189.5 cm (65¹/₂×74¹/₂″). Collection Joachim Jean Aberbach, New York

61 *Le déjeuner sur l'herbe*, 1969
Oil, 180×190.5 cm (71×75″). Private collection, Paris

62 *Picnic*, 1973
Oil, 188×195 cm (74×76³/₄″). Collection Peter Schamoni, Munich

63 *Colombian still-life*, 1973
Oil, 187×189 cm (73¹/₂×74¹/₂″). Collection Hanoj Pérez, Bogotá, Colombia

64 *Chest still-life*, 1970
Oil, 183×167.5 cm (72×66″). Collection Peter Findlay, New York

65 *Pineapples*, 1971
Oil, 164×193 cm (64¹/₂×76″). Collection Stan Westreich, Washington, D.C.

66 *The butcher's table*, 1969
Oil, 180.5×155.5 cm (71×61″). Hopkins Center Art Galleries, Dartmouth College, Hanover, N.H.

67 *Oranges*, 1970
Oil, 107×94 cm (42×37″). Private collection

68 *Homage to Sanchez Cotan*, 1972
Pastel, 108×123 cm (42¹/₂×48¹/₂″). Aberbach Fine Art, New York

69 *Boy eating water-melon*, 1972
Oil, 164×171.5 cm (64¹/₂×67¹/₂″). Collection Joachim Jean Aberbach, New York

70 *Fruit-basket*, 1972
Pastel, 123×141 cm (48¹/₂×55¹/₂″). Private collection, New York

71 *Maruja*, 1970
Oil, 151×119 cm (59¹/₂×47″). Collection Valentino, Rome

72 *Child from Vallecas, after Velasquez*, 1971
Pastel, 174×126 cm (68¹/₂×49¹/₂″). Collection Joachim Jean Aberbach, New York

73 *Pedro with rocking-horse*, 1971
Pastel, 175×135.5 cm (69×53½″). Collection Joachim Jean Aberbach, New York

74 *Portrait of Claude Bernard*, 1972
Oil, 255×145 cm (100½×57″). Collection Claude Bernard, Paris

75 *Mr. Frank Lloyd and his family in Paradise Island*, 1972
Oil, 233×192 cm (92×75½″). Collection Frank Lloyd, Bahamas

76 *Study with the male model*, 1972
Pastel, 170×123 cm (67×48½″). Private collection, Chicago, Ill.

77 *Minister of War*, 1973
Pastel, 163×122 cm (64×48″). Private collection, Paris

78 *Field Marshal*, 1970
Oil, 194×124.5 cm (76½×49″). Private collection, New York

79 *Military Junta*, 1973
Oil, 234×195 cm (92×76¾″). Collection Harry N. Abrams, New York

80 *Man smoking*, 1973
Oil, 136×96 cm (53½×37¾″). Collection Herman Igell, Sweden

81 *The First Lady*, 1970
Pastel, 159×124.5 cm (62½×49″). Collection Joachim Jean Aberbach, New York

82 *Delfina*, 1972
Oil, 126×95.5 cm (49½×37½″). Collection Michael Heidenberg, New York

83 *The mother of the Cardinal*, 1972
Oil, 221×160 cm (87×63″). Collection José Pérez, Bogotá, Colombia

José Mejia y Mejia, 'Nuevo Artista,' first literary supplement of *El Colombiano*, Medellín, Colombia, 1949.

Carlos Jimenez Gomez, 'El pintor Fernando Botero,' *El Liberal*, Bogotá, May, 1951.

Walter Engel, *Botero*, Editorial Eddy Torres, Bogotá, 1952. Text and 20 reproductions, edition of 350 copies.

Marta Traba, 'Pan America: Five Contemporary Colombians,' *Art in America*, New York, vol. 48, 1960, pp. 110–11.

Jack Kroll, 'Fernando Botero at Contemporaries,' in: 'Reviews and previews: New Names this month,' *Art News*, New York, vol. 61, Dec., 1962, p. 20.

Marc Berkowitz, 'Arte de America y España, Madrid und Barcelona,' *Das Kunstwerk*, Baden-Baden, vol. XVII, Aug.–Sept., 1963, pp. 36, 55–58.

Hernan Diaz/Marta Traba, *Seis Artistas Contemporáneos Colombianos: Obregón, Ramirez, Botero, Grau, Wiedemann, Negret*, Alberto Barco, Bogotá, 1963. Edition of 1028 numbered copies.

Donald Judd, 'Exh. at Contemporaries–Fernando Botero,' *Arts Magazine*, New York, vol. XXXVII, Jan., 1963, p. 55.

Agnoldomenico Pica, 'Edizioni di architettura: on "Paul F. Damaz, Art in Latin American Architecture, N.Y. 1963,"' *Domus*, Milan, no. 409, Dec., 1963, p. 2.

Colette Roberts, 'Les expositions à l'étranger–Lettre de New York,' *Aujourd'hui*, Boulogne-sur-Seine, vol. 8, Oct., 1964, pp. 52–53.

N. Rosenthal, 'New York: around the world in 20 galleries,' *Art in America*, New York, vol. 52, Oct., 1964, pp. 119–21.

Rafael Squirru, 'Spectrum of styles in Latin America,' *Art in America*, New York, vol. 52, Feb., 1964, pp. 81–86.

Malerei aus Süd-Amerika (catalogue), Galerie Buchholz, Munich, 1965.

Thomas M. Messer, 'Latin America: Esso Salon of young artists,' *Art in America*, New York, vol. 53, Oct.–Nov., 1965, pp. 120–21.

Fernando Botero (catalogue), Staatliche Kunsthalle, Baden-Baden, and Galerie Buchholz, Munich, 1966.

'Fernando Botero, Piñatas in Oil,' *Time*, New York, vol. 88, no. 27, 1966.

Tracy Atkinson, *Fernando Botero, recent works* (catalogue), Milwaukee Art Center, 1967.

Jean Franco, *The Modern Culture of Latin America: Society and the Artists*, Harmondsworth, 1967.

87 *Botero* (catalogue), Gallería Juana Mordó, Madrid, 1968.

'Botero,' *Visión*, Bogotá, Feb. 2, 1968.

'Botero–Feiste Elsbeth,' *Der Spiegel*, Hamburg, no. 23, 1968.

Klaus Gallwitz, 'Fernando Botero,' *Das Kunstwerk*, Stuttgart, vol. XXI, no. 7/8, April–May, 1968, pp. 3–14.

Ernst Wuthenow, *Botero* (catalogue), Galerie Buchholz, Munich, 1968.

Fernando Arrabal, *Botero–peintures, pastels, fusains* (catalogue), Galerie Claude Bernard, Paris, 1969.

Jacqueline Barnitz, 'Three artists at the C.I.R.: Ramirez, Macció and Botero in New York,' *Arts Magazine*, New York, vol. XLIII, April, 1969, pp. 42–44.

'Botero y su Obra,' *Visión*, Bogotá, May 23, 1969.

'Exhibitions–France and Switzerland: Fernando Botero,' *Studio International*, London, vol. 178, no. 37, July/Aug., 1969.

J. Gállego, 'Crónica de Paris,' *Goya*, no. 93, Nov., 1969, p. 171.

Klaus Gallwitz, *Fernando Botero* (catalogue), Center for Inter-American Relations, Art Gallery, New York, 1969.

E. García-Herráiz, 'Fernando Botero–Crónica de Nueva York,' *Goya*, Madrid, no. 93, Nov., 1969, p. 179.

M. Peppiatt, 'Exhibition in Paris,' *Art International*, Lugano, vol. XIII, Dec., 1969, p. 77.

P. Schjeldahl, 'Fernando Botero: Exh. at the Center of Inter-American Relations,' *Art International*, Lugano, vol. XIII, May, 1969, p. 38.

L. H. S., 'Reviews and Previews: Fernando Botero at the Center for Inter-American Relations,' *Art International*, Lugano, vol. XIII, May, 1969, p. 38.

Herbert Asmodi, 'Botero – Ein Interview von Herbert Asmodi,' *Die Kunst und das schöne Heim*, Munich, vol. 82, no. 11, Nov., 1970, pp. 668–71.

Jacqueline Barnitz, 'Botero: Sensuality, volume, colour,' *Art and Artists*, London, vol. V, Dec., 1970, p. 50–53.

Botero (catalogue), Galerie Buchholz, Munich, 1970. Texts by Tracy Atkinson, Klaus Gallwitz, Alvaro Mutis.

Fernando Botero (catalogue), Hanover Gallery, London, 1970.

J. Burr, 'Exhibition at Hanover Gallery, London,' *Apollo*, London, vol. 92, Oct., 1970, p. 307.

B. Denvir, 'Exhibition at Hanover Gallery, London,' *Art International*, Lugano, vol. XIV, Dec., 1970, pp. 52–54.

'Exposición: Fernando Botero,' *Goya*, Madrid, no. 97, July, 1970, p. 41.

Lothar Romain, 'Fernando Botero–Staatl. Kunsthalle, Baden-Baden,' *Das Kunstwerk*, Stuttgart, vol. XXIII, June, 1970, p. 78.

Gottfried Sello, 'Botero, Paradies der Dicken,' *Die Zeit*, Hamburg, April 3, 1970.

'Neighbours to the North and South,' *The Connoisseur*, London, vol. 177, May, 1971, pp. 57–58.

René Barotte, 'Botero, du gigantisme à la tendresse,' *L'Aurore*, Paris, Dec. 27, 1972.

Wibke von Bonin, 'An interview with Fernando Botero,' *Botero* (catalogue), Marlborough Gallery, New York, 1972.

'Fernando Botero at Marlborough,' *Arts Magazine*, New York, vol. XLVI, April, 1972, p. 66.

Fernando Botero (catalogue), Galerie Buchholz, Munich, 1972.

'Exh. Fernando Botero at Marlborough Gallery, New York,' *Art International*, Lugano, vol. XVI, April, 1972, p. 35.

'Exposición: Botero at Marlborough, New York,' *Goya*, Madrid, no. 107, March, 1972, p. 324.

Gerrit Henry, 'Reviews and Previews: Fernando Botero at Marlborough,' *Art News*, New York, vol. 71, March 1972, p. 12.

Jean Paget, Introduction to the catalogue *Botero*, Galerie Claude Bernard, Paris, 1972.

Juliane Roh, 'Zeichnungen von Fernando Botero, Galerie Buchholz, München,' *Das Kunstwerk*, Stuttgart, vol. XXV, Nov., 1972, p. 78.

Peter Schjeldahl, 'Surrealist Fernando Botero Deflates the Effete and the Elite,' *The New York Times*, Feb. 20, 1972.

Ursula Bode, 'Zeichnungen wie ruhige Atemzüge – eine neue Dimension im Werk Boteros,' *Brusberg Berichte*, Hanover, no. 18, 1973, pp. 45–85.

'Exh. Botero at Claude Bernard Gallery, Paris,' *Art International*, Lugano, vol. XVII, Jan., 1973, p. 27.

Helen M. Franc, *An invitation to see: 125 paintings from the Museum of Modern Art*, New York, 1973, p. 61.

Alvaro Medina, 'Botero encuentra a Botero,' *ECO*, Bogotá, Dec., 1973.

Helga Muth, 'Botero–Galerie Claude Bernard, Paris,' *Das Kunstwerk*, Stuttgart, vol. XXVI, Jan., 1973, p. 65.

Phaidon Dictionary of 20th Century Art, Phaidon Press, London and New York, 1973, p. 46.

Mario Rivero, *Botero*, Plaza Janes, Barcelona, 1973.

Liliane Touraine, 'Lettre de Paris–Chronique de janvier-février,' *Art International*, Lugano, vol. XVII, April, 1973, p. 72.

'Un falso ingenuo: Botero,' *Goya*, Madrid, no. 112, Jan., 1973, p. 236.

Fernando Botero–ein Kontinent unter dem Vergrößerungsglas (catalogue), Marlborough Galerie, Zurich, 1974.

Gustav René Hocke, 'A Continent under the Magnifying Glass,' *Art International*, Lugano. vol. XVIII, Dec., 1974, pp. 19–21, 34.

Federico Undiano, 'Fernando Botero,' *Mundo Hispanico*, Madrid, Jan., 1974.

Fernando Botero (catalogue), Museum Boymans-van Beuningen, Rotterdam, 1975. Texts by R. Hammacher-van den Brande, Titia Berlage.

Ton Frenken, 'Portret van een militaire junta,' *Eindhovens Dagblad*, April 5, 1975.

Carlos Jimenez Gomez, *Retrato de familia*, Editorial Visión, Bogotá, 1975.

Sam Hunter, Introduction to the catalogue *Botero*, Marlborough Gallery, New York, 1975.

Jan Juffermans, 'Fernando Botero, Kunstschilder,' *De Nieuwe Linse*, April 29, 1975.

G. Kruis, 'Fernando Botero's mensbeeld: vertederend monsterachtig,' *Nieuw Haagsche*, April 5, 1975.

Hans Redeker, 'Botero schildert: de mensheid buiten proporties,' *NRC Handelsblad*, April 15, 1975.

Werner Spies, 'Die Inflation des Fleisches–Fernando Boteros Malerei unter dem Konvexspiegel,' *Frankfurter Allgemeine Zeitung*, Sept. 27, 1975.

German Arciniegas, *Botero*, Harry N. Abrams, New York, 1976.

Botero–Aquarelles et Dessins (catalogue), Galerie Claude Bernard, Paris, 1976. Text by Severo Sarduy.